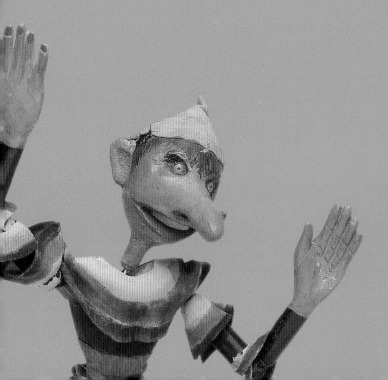

The Hand-Carved Marionettes of Gustave Baumann

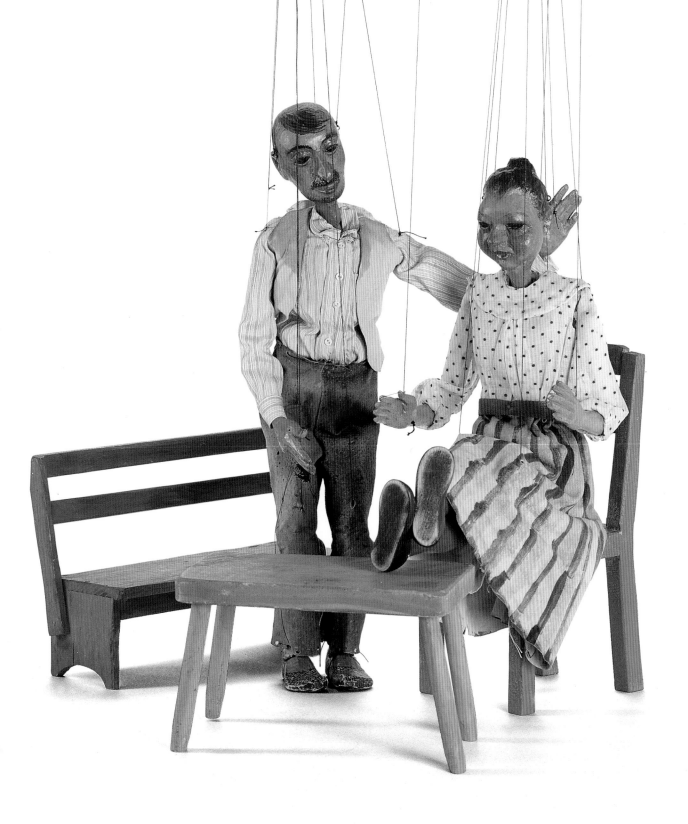

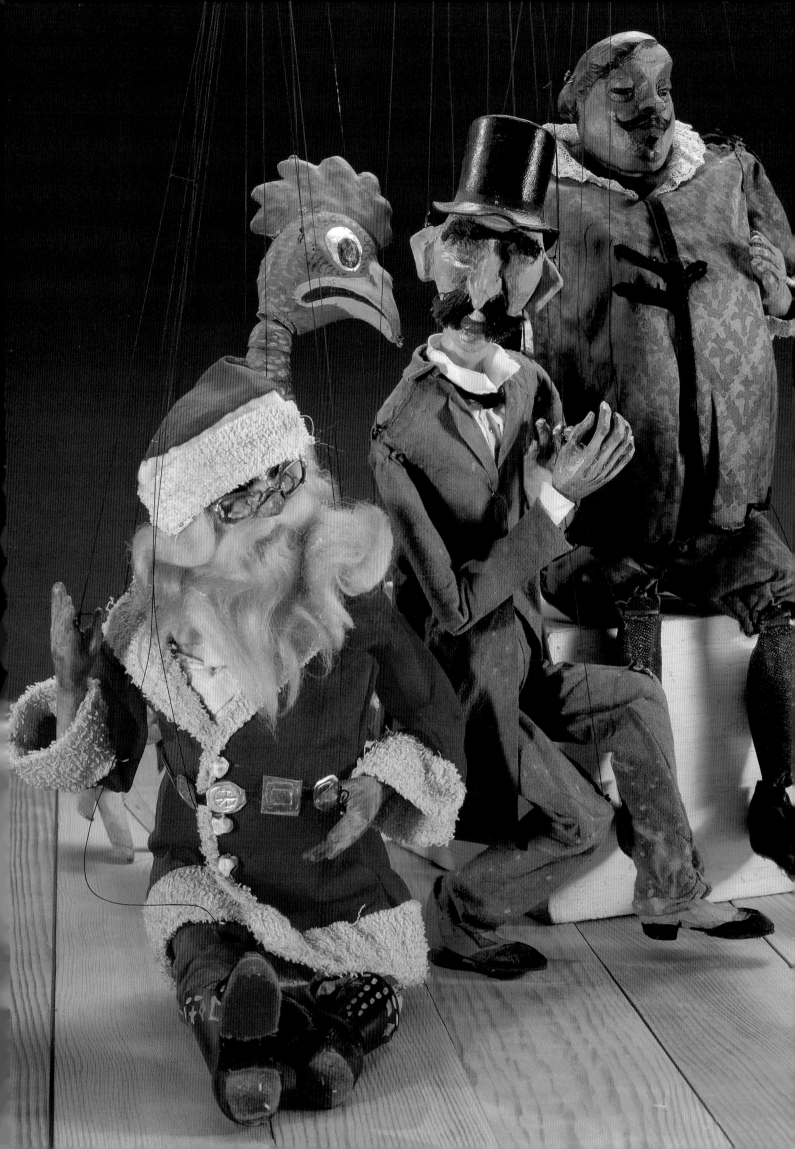

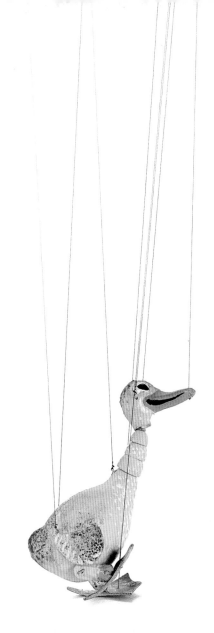

The Hand-Carved Marionettes of Gustave Baumann

Share Their World

For Aunt Ellen and Uncle Ted—
With much love always, Ellen Zieselman 12/99

By Ellen Zieselman

With an Essay by Elizabeth Cunningham

Photography by Blair Clark

Museum of Fine Arts, Santa Fe

Produced in Hong Kong.
Project editor: Mary Wachs
Design and production: Mary Sweitzer Design
Composition: Set in Memphis with Franklin Gothic Extra Condensed Display.
This book was made possible with a generous grant from the Kemper Foundation.

ISBN 0-9675106-0-0

Contents

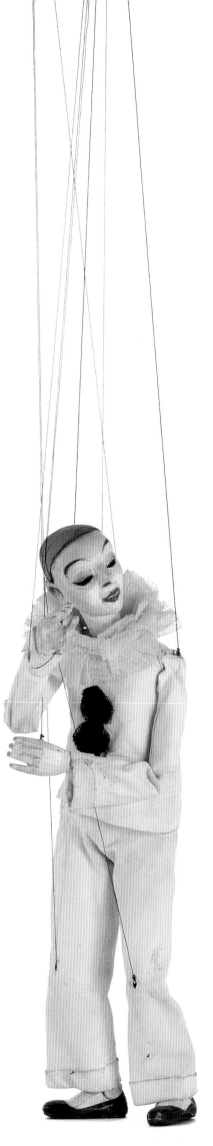

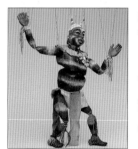

Foreword

Although best known for his color woodblock prints, Gustave Baumann's range of talent and expression was remarkably broad. Born in Germany in 1881, Baumann emigrated to Chicago with his family at the age of ten. The oldest of four children, he left school at sixteen to work in an engraving house. By 1900 he was a commercial artist in the studio of Curtis Gandy, and three years later he had his own advertising studio.

To expand his training, Baumann studied the applied arts in Munich in 1905, and there learned to carve wood and to absorb the fundamentals of printmaking, skills that would figure prominently both in his career as a fine-art color woodcut printmaker and in his developing fascination with marionette theater.

Baumann left the world of commercial art by and by and gravitated toward a printmaking career that depended upon an artist's response to nature and to the celebration of a life lived close to its source. He found both in abundance in New Mexico, where he traveled in 1918 to visit the flourishing art colony at Taos and to open an exhibit of his prints at Santa Fe's Museum of Fine Arts. Intending to move on and further his artistic curiosity, he instead found in New Mexico a range of subject matter and a depth of cultural expression that sustained him for the more than fifty years he lived there.

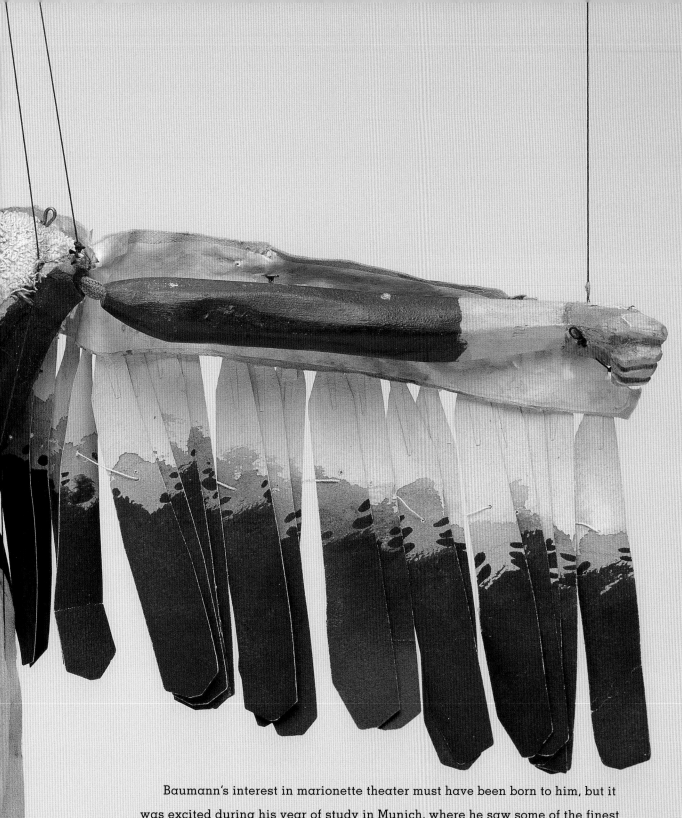

Baumann's interest in marionette theater must have been born to him, but it was excited during his year of study in Munich, where he saw some of the finest puppet theater that Europe had to offer. By 1929, when he attended a performance by the great puppet master Tony Sarg, Baumann had become involved in Santa Fe's community theater on the urging of cultural maven Mary Austin. With his marriage in 1925 to actress Jane Devereux Henderson, it seemed all the elements necessary to put together a serious effort were at last in place.

The Eagle Dancer puppets were choreographed to replicate the steps Baumann observed at local Pueblo festival dances.

9

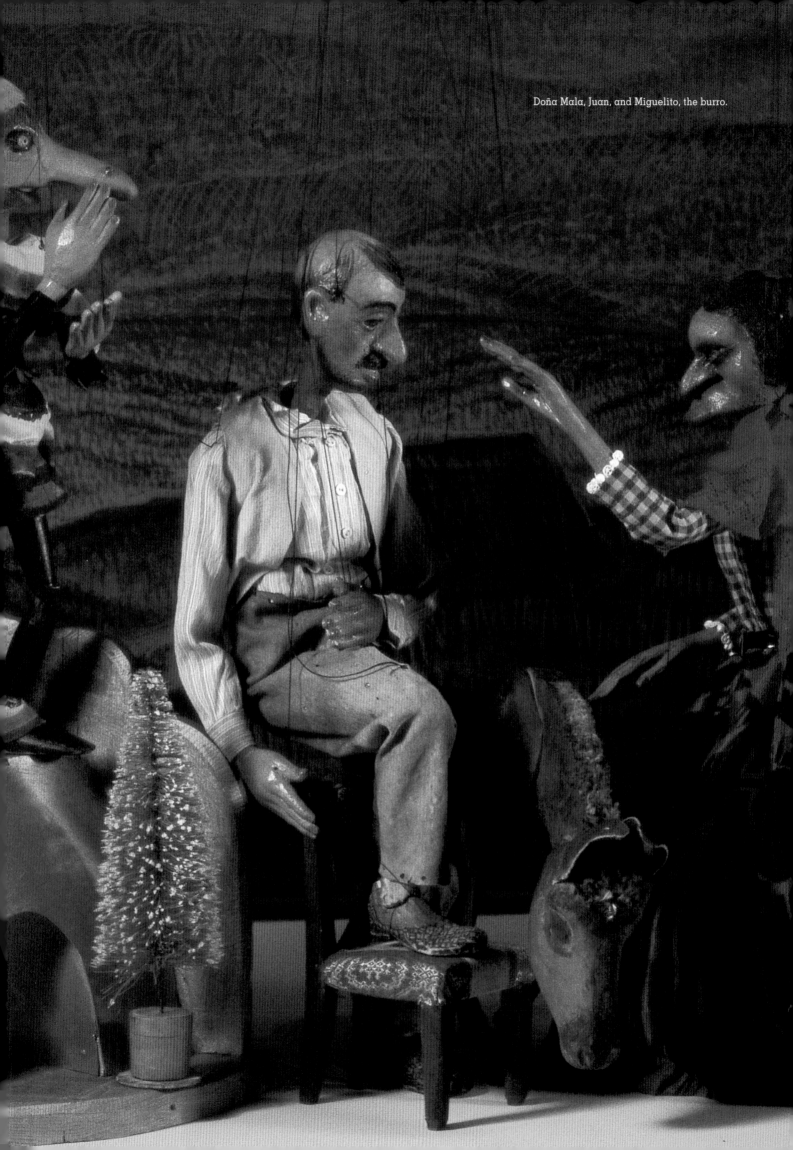

Doña Mala, Juan, and Miguelito, the burro.

Preface

by Ann Baumann

What was it like to grow up in Santa Fe, as the only child of artistic parents, in a home surrounded by paintings, woodblock prints, and a troupe of marionettes? My father's creations and my mother's involvement with the marionettes were a natural part of my childhood.

The stage was permanently placed in our large living room, a huge piece of furniture. Several marionettes always hung at the rear of the stage, with the remainder packed in the two large wooden chests that doubled for the bridge (the platform on which the puppeteers stood as they worked the marionettes). The only time the stage moved was when the marionette company traveled to perform. It was not uncommon for Mother to play one or more of the marionettes for the pleasure of our guests.

When new marionettes were being carved, Father would quite often bring them from the studio for Mother to design costumes and dress them. He always made the leather costumes but generally she sewed the cloth ones. I remember a special box filled with all kinds of fabric: old clothes, fabric samples, and interesting fabrics bought from local stores or when out of town trips were taken.

At times I became quite emotionally involved with the marionettes. In particular, I remember my impression of Oscar Wilde's play *Birthday of the Infanta*, performed when I was about eight or nine. The Infanta, a cruel young woman, had been given a "toy," a hunchbacked dwarf! When she commanded the dwarf to dance for her, her manner seemed so cruel to me that I burst into tears!

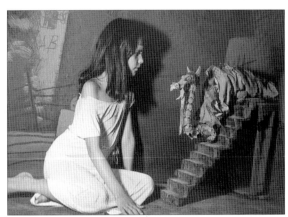

According to my recollection, the photographer Ruth Frank was at the house that evening to take photos of the marionettes. I was already in bed, and at Ruth's request Mother got me up. So Ruth took photos, nightgown and all. I'm sitting on the stage with the Dragon. The design on the backdrop was painted by my father from my drawings.
Courtesy of Ann Baumann.

The Christmas performances required preparation from late summer on. Mother recruited the puppeteers, generally from among our family friends who volunteered when they weren't working. They often repeated seasons. Most of the training and rehearsals occurred on weekends and in the evenings. Mother taught the actual manipulation of the marionettes, with my father sitting in front to comment, correct, or otherwise criticize the action. When it came time for the performances (there were two or three plays performed at one time, as I recall), the living room was cleared of our furniture, and benches rented from the local moving and storage company were brought in. The last performances of the holiday season occurred on Christmas Eve. When they were over, it was the family tradition to go to San Felipe Pueblo for the midnight Christmas Eve dance. Incidentally, it was at the 1923 Pueblo ceremonial dance that my parents met.

All of this: the stage in the living room with marionettes hanging at the back; my mother, the actress, entertaining guests with marionette play; and the Christmas performances were a wonderful part of my young life. I cherish memories of my childhood with the marionettes, who speak to me now as then. With their publication in this book, we can offer the same delight to others. I'm glad that the Museum of Fine Arts shares my appreciation for this part of my father's work.

11

A Small, Untroubled World

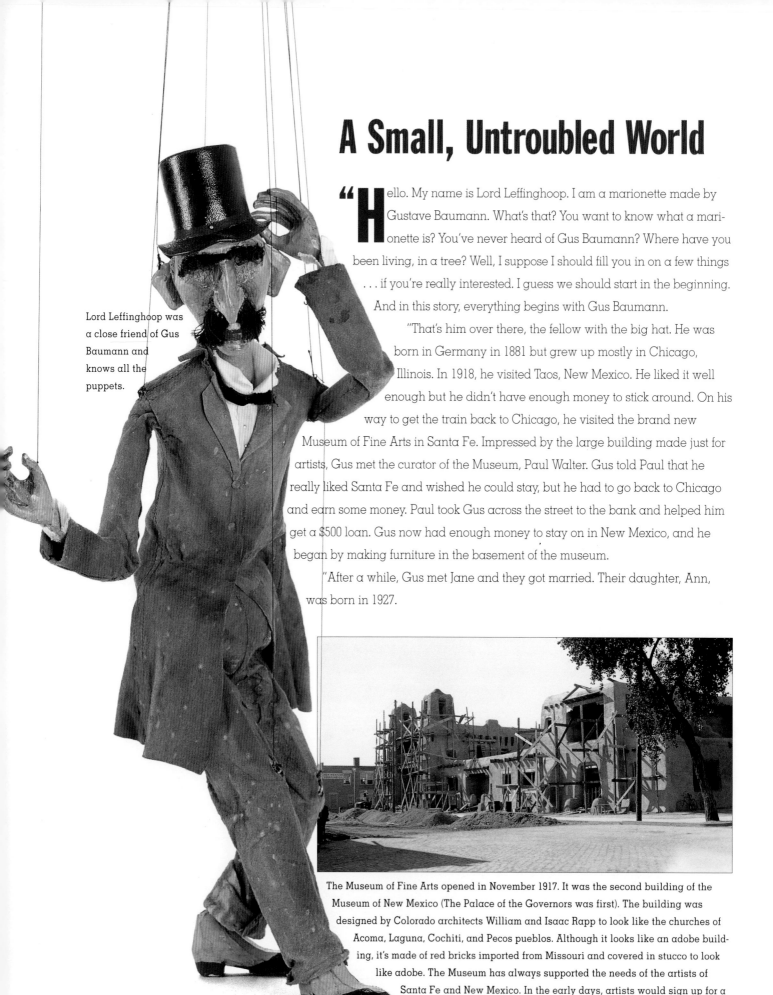

Lord Leffinghoop was a close friend of Gus Baumann and knows all the puppets.

"**H**ello. My name is Lord Leffinghoop. I am a marionette made by Gustave Baumann. What's that? You want to know what a marionette is? You've never heard of Gus Baumann? Where have you been living, in a tree? Well, I suppose I should fill you in on a few things . . . if you're really interested. I guess we should start in the beginning. And in this story, everything begins with Gus Baumann.

"That's him over there, the fellow with the big hat. He was born in Germany in 1881 but grew up mostly in Chicago, Illinois. In 1918, he visited Taos, New Mexico. He liked it well enough but he didn't have enough money to stick around. On his way to get the train back to Chicago, he visited the brand new Museum of Fine Arts in Santa Fe. Impressed by the large building made just for artists, Gus met the curator of the Museum, Paul Walter. Gus told Paul that he really liked Santa Fe and wished he could stay, but he had to go back to Chicago and earn some money. Paul took Gus across the street to the bank and helped him get a $500 loan. Gus now had enough money to stay on in New Mexico, and he began by making furniture in the basement of the museum.

"After a while, Gus met Jane and they got married. Their daughter, Ann, was born in 1927.

The Museum of Fine Arts opened in November 1917. It was the second building of the Museum of New Mexico (The Palace of the Governors was first). The building was designed by Colorado architects William and Isaac Rapp to look like the churches of Acoma, Laguna, Cochiti, and Pecos pueblos. Although it looks like an adobe building, it's made of red bricks imported from Missouri and covered in stucco to look like adobe. The Museum has always supported the needs of the artists of Santa Fe and New Mexico. In the early days, artists would sign up for a time to exhibit their art work in the museum. Today, curators decide what works by which artists hang in the museum.

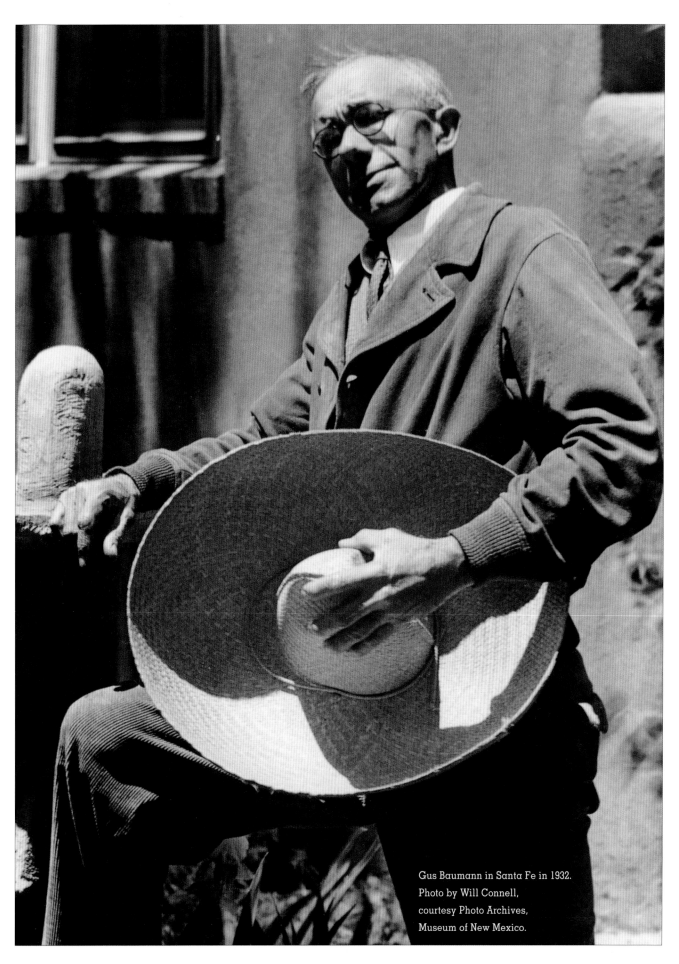

Gus Baumann in Santa Fe in 1932.
Photo by Will Connell,
courtesy Photo Archives,
Museum of New Mexico.

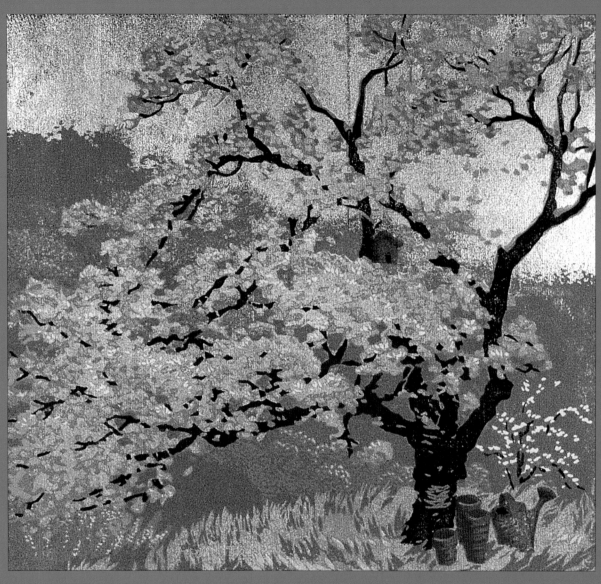

"Mostly, Gus was an artist. He had a studio, and he created the most beautiful woodblock prints. Here's one, next to one of the blocks used to make it. When you make a print like this, you put ink on the wood, paper on top of the inked wood, and apply pressure. When you peel off the paper, the image is transferred from the wood to the paper. You can make as many copies as you want this way. The tricky part is that you can only put one color on a block of wood at a time, so that if you want more than one color in your print (say, six colors) you have to carve that many different wood blocks. In order to create this print, Gus carved eight blocks of wood! Here's my favorite, the one with just the flower pots.

"So, as you can tell by looking at some of these woodblock prints, Gus was a really talented woodcarver and a great painter. He also built furniture, such as this chair that the Museum of Fine Arts owns.

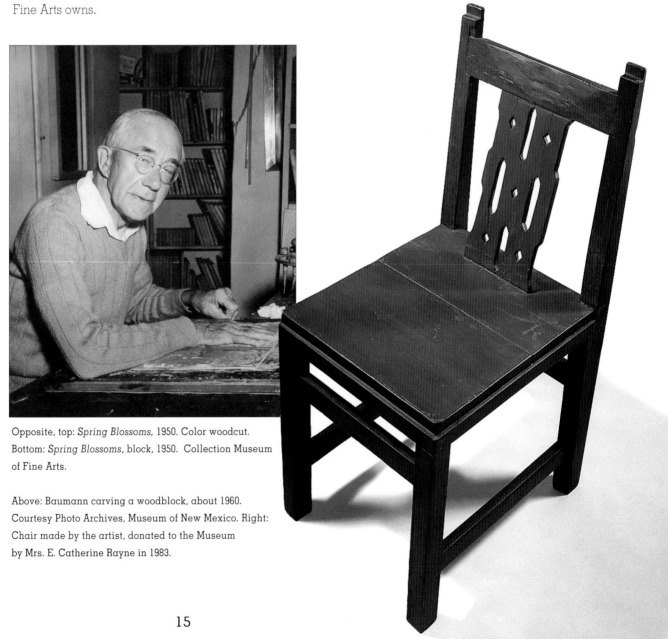

Opposite, top: *Spring Blossoms*, 1950. Color woodcut. Bottom: *Spring Blossoms*, block, 1950. Collection Museum of Fine Arts.

Above: Baumann carving a woodblock, about 1960. Courtesy Photo Archives, Museum of New Mexico. Right: Chair made by the artist, donated to the Museum by Mrs. E. Catherine Rayne in 1983.

15

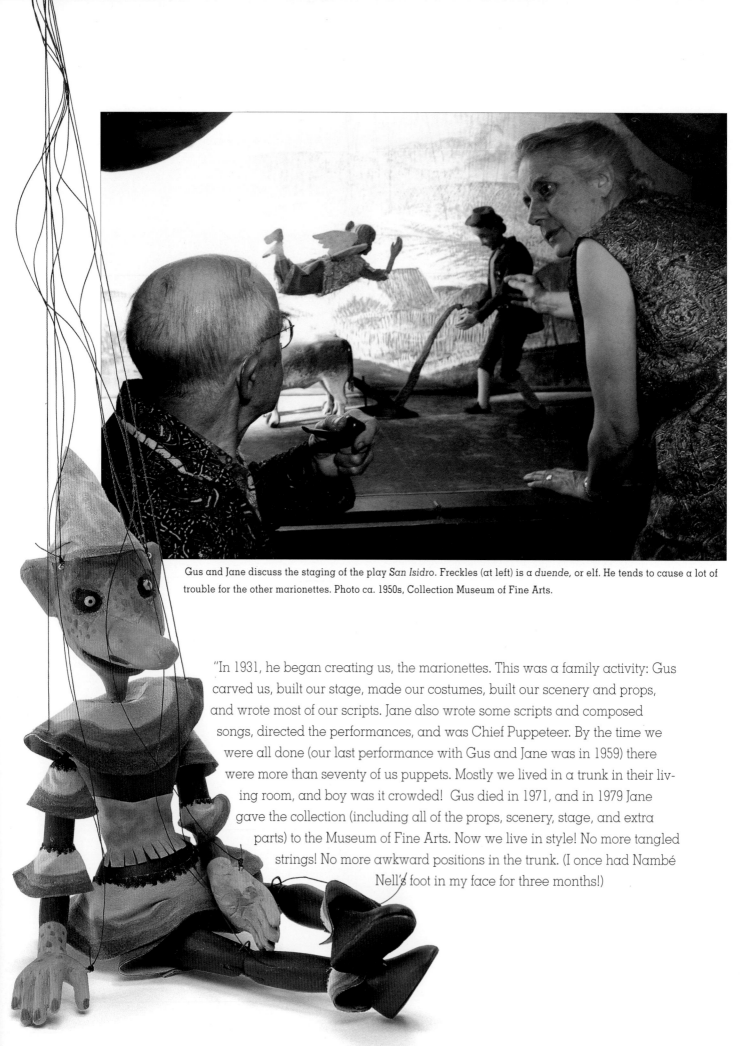

Gus and Jane discuss the staging of the play *San Isidro*. Freckles (at left) is α *duende*, or elf. He tends to cause α lot of trouble for the other marionettes. Photo ca. 1950s, Collection Museum of Fine Arts.

"In 1931, he began creating us, the marionettes. This was α family activity: Gus carved us, built our stage, made our costumes, built our scenery and props, and wrote most of our scripts. Jane also wrote some scripts and composed songs, directed the performances, and was Chief Puppeteer. By the time we were all done (our last performance with Gus and Jane was in 1959) there were more than seventy of us puppets. Mostly we lived in α trunk in their living room, and boy was it crowded! Gus died in 1971, and in 1979 Jane gave the collection (including all of the props, scenery, stage, and extra parts) to the Museum of Fine Arts. Now we live in style! No more tangled strings! No more awkward positions in the trunk. (I once had Nambé Nell's foot in my face for three months!)

16

"What's Life Like for a Marionette?"

"**T**hat's a great question. There are so many parts to our lives, it's hard to know where to begin . . ."

Freckles: "What's the matter? Is your hat too tight? You begin at the start, everyone knows that!"

Leffinghoop: "Oh, Freckles, is that you? You are quite right. The start is a good place to begin. Your start is a great place to begin. Because you are very young. You were just made a few years ago. You are a copy of the original Freckles, made by Gus."

See, this is the trunk I was telling you about. It's pretty cool looking, but believe me, it was crowded in there!

17

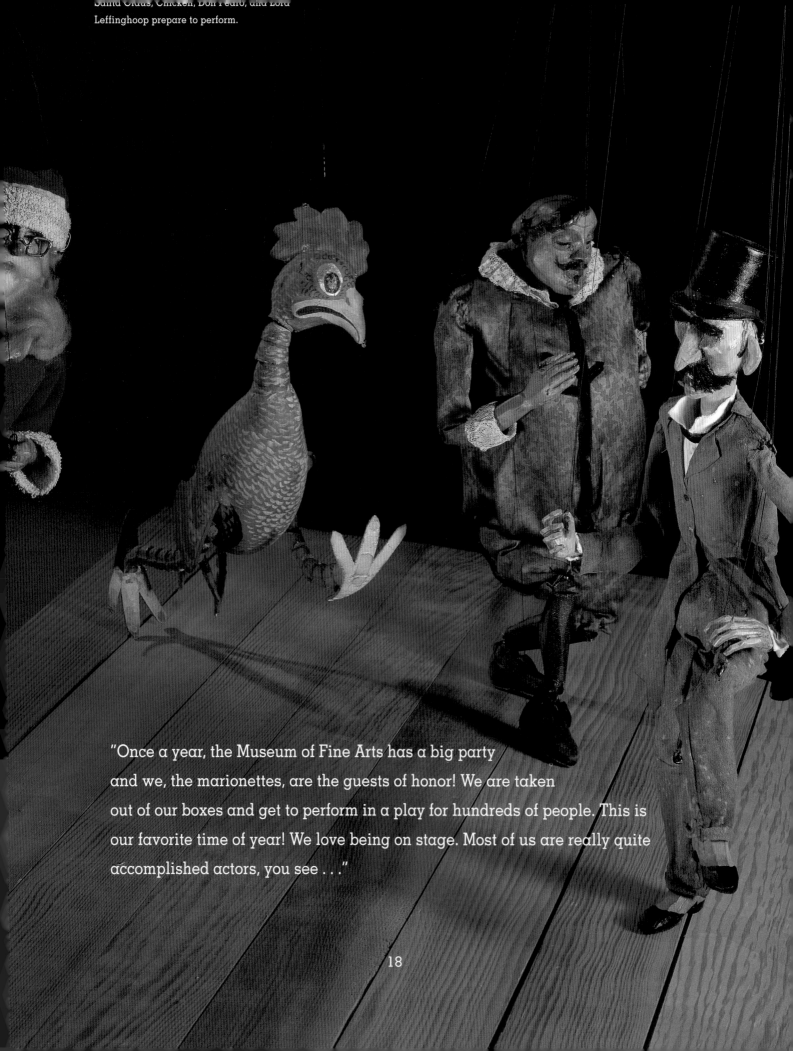

"Once a year, the Museum of Fine Arts has a big party
and we, the marionettes, are the guests of honor! We are taken
out of our boxes and get to perform in a play for hundreds of people. This is
our favorite time of year! We love being on stage. Most of us are really quite
accomplished actors, you see . . ."

Freckles: "Hey! You were going to tell about me! Tell them about me!! ME!!"

Leffinghoop: "Ahem. Well, yes, alright. About you. Yes. Well, your story is really very important, you are correct."

Freckles: "Well? Get on with it. Commence with the starting of the beginning of the story."

Leffinghoop: "It actually follows from the story of our visits to the conservation lab. The people there felt that some of us, well, most of us actually, were really too delicate to spend too much time out of our boxes. So the museum has been raising money to create replicas, or copies, of some of the more popular marionettes."

Freckles: "That's us! We're popular! We're always in demand. People love us!"

Leffinghoop: "Yes, well, anyway . . . we've created new versions of Freckles, his brother Warts, and Miguelito, the cute burro."

Miguelito: "Tell them how we were made. It's really interesting."

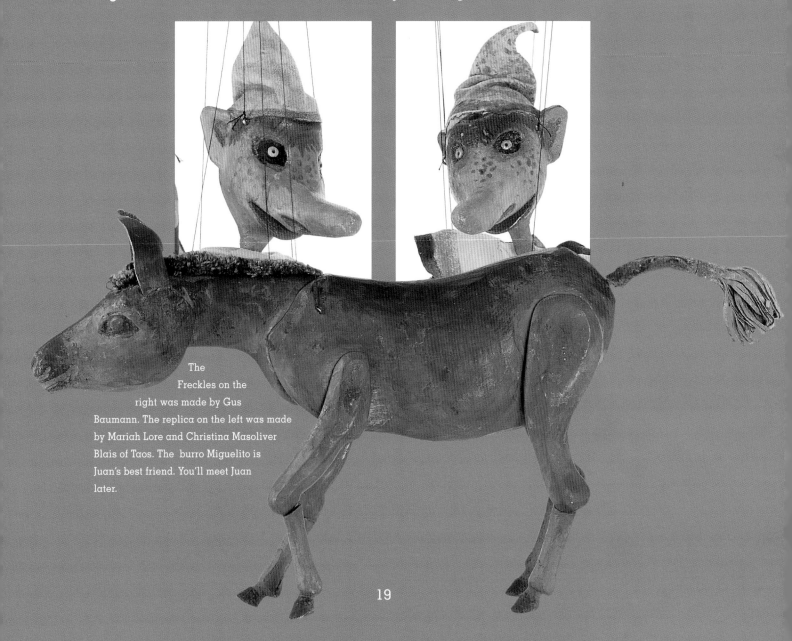

The Freckles on the right was made by Gus Baumann. The replica on the left was made by Mariah Lore and Christina Masoliver Blais of Taos. The burro Miguelito is Juan's best friend. You'll meet Juan later.

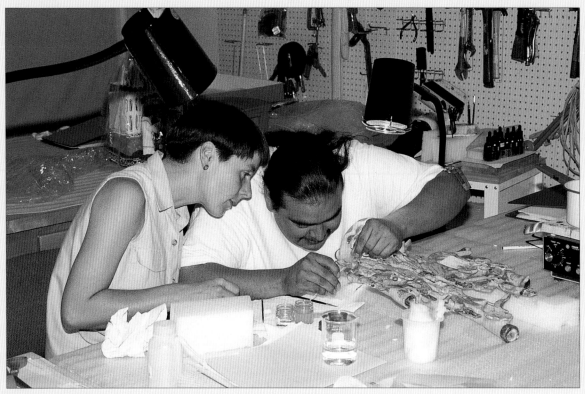

The conservation lab.

"In 1995, the Museum of Fine Arts realized that some of us were falling apart. They took us to their Conservation Department—like a museum hospital—and we were all treated and stabilized. The people we met there were all really nice to us. They cleaned our costumes, checked to be sure our strings were attached properly, and that we had all of our parts! The lab was pretty interesting, I'll tell you!

"They fix all kinds of stuff up there: pottery, paintings, fabrics, sculptures, photographs, every type of art that museums collect. The people who work there know a lot about science, chemistry, painting, and even bugs. It's their job to make sure that the things that the museum owns don't fall apart or get wrecked. Did you know that one fingerprint given enough time can ruin a painting? Or that if you leave a print or photograph out in the light too long the picture will disappear? It's all true. The conservation folks make sure that we are safe and well protected.

The Big Day (Country Circus), 1909. Color woodcut. Collection Museum of Fine Arts.

20

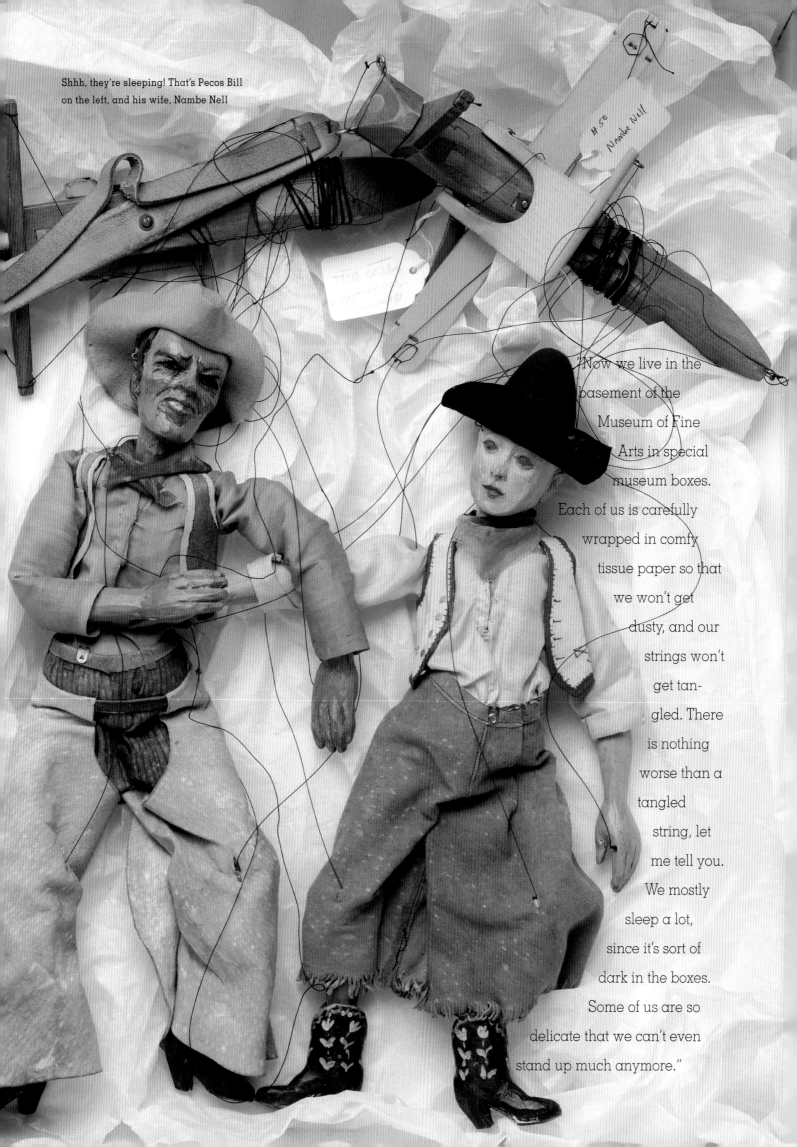

Shhh, they're sleeping! That's Pecos Bill on the left, and his wife, Nambe Nell

H 56
Nambe Nell

"Now we live in the basement of the Museum of Fine Arts in special museum boxes. Each of us is carefully wrapped in comfy tissue paper so that we won't get dusty, and our strings won't get tan-gled. There is nothing worse than a tangled string, let me tell you. We mostly sleep a lot, since it's sort of dark in the boxes. Some of us are so delicate that we can't even stand up much anymore."

Making New Puppets

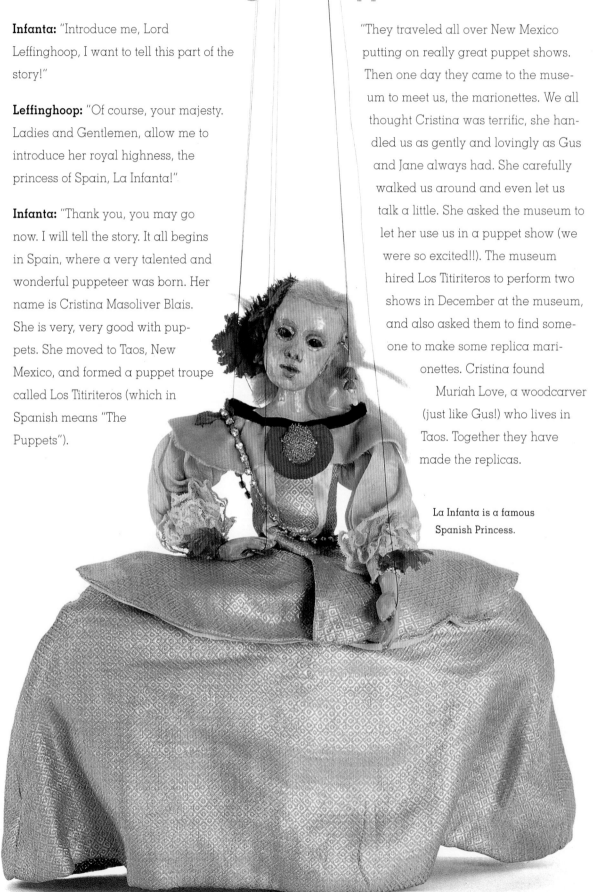

Infanta: "Introduce me, Lord Leffinghoop, I want to tell this part of the story!"

Leffinghoop: "Of course, your majesty. Ladies and Gentlemen, allow me to introduce her royal highness, the princess of Spain, La Infanta!"

Infanta: "Thank you, you may go now. I will tell the story. It all begins in Spain, where a very talented and wonderful puppeteer was born. Her name is Cristina Masoliver Blais. She is very, very good with puppets. She moved to Taos, New Mexico, and formed a puppet troupe called Los Titiriteros (which in Spanish means "The Puppets").

"They traveled all over New Mexico putting on really great puppet shows. Then one day they came to the museum to meet us, the marionettes. We all thought Cristina was terrific, she handled us as gently and lovingly as Gus and Jane always had. She carefully walked us around and even let us talk a little. She asked the museum to let her use us in a puppet show (we were so excited!!). The museum hired Los Titiriteros to perform two shows in December at the museum, and also asked them to find someone to make some replica marionettes. Cristina found Muriah Love, a woodcarver (just like Gus!) who lives in Taos. Together they have made the replicas.

La Infanta is a famous Spanish Princess.

Nuts and bolts and spare parts—tools of the wood carver's trade

"First they measure each part of the puppet. Each hand, the shape and size of the head, the tummy, feet, everything. Then they carefully examine everything about the marionette. For example, when they were looking at Freckles, they realized that Gus had used pieces of lead on the soles of Freckles' feet! Freckles couldn't remember exactly why Gus used the lead, but Muriah and Cristina think it's so you can hear his footsteps when he walks. (Since Freckles seems to get into trouble a lot, being able to hear his footsteps is a good thing, that way he can't sneak up on people!)

"Once they have the measurements, and know everything about the puppet, Muriah carves each piece and Cristina makes a new costume to match the original. Gus used all sorts of things when he made us, like scraps of things he had lying around in his studio. Some of us have old nuts and bolts and spare parts from things that they don't even make anymore. But its pretty hard to tell which is the original Freckles and which is the replica Freckles. Can you tell? (The answer is under their picture on page 19!) Once the museum gets enough replica marionettes the replicas will travel around New Mexico with Cristina and Los Titiriteros performing all the old plays and some new ones, too. This will be very exciting, even for the original marionettes, because we will have to work very hard with the replicas to teach them all the parts."

23

The Puppets Prepare to Perform

Nambé Nell: "Howdy there. My name is Nambé Nell. I own a mine and am married to Pecos Bill. That's his horse, Old Paint. We were in one of the first plays produced by Gus and Jane. Their puppet theater was called *Teatro Duende* (which sort of means Elf Theater), and they performed our play in Colorado at the Central City Opera House. I was a big star, and almost didn't get to marry Bill since Lord Leffinghoop (have you met him?) tried to saw him in half! But that's another story entirely. Leffinghoop swears it was only a play, and that he would *never* really try to saw Bill in half. We believe him, but we sleep in separate boxes, just to be sure."

Bill: "Tell them about our current performances, Nell. Tell them about Juan and Miguelito and Doña Mala."

Nell: "OK, pipe down! You'd think *he* was the big star! Let's see. Back when Gus was alive we used to have performances pretty regular. Well, until he and Jane got tired of us (some marionettes can be very demanding!). Gus called us his 'little people,' and once complained that 'marionettes are the

(Turn to page 37 to see just how sinister Lord Leffinghoop can be!)

ever new problem-children!' Imagine that. Well, in 1959 we gave our final performance. It was around Christmas at the Museum of International Folk Art. As I'm sure Leffinghoop told you, after that we lived in a trunk in the Baumann's living room. I had his face stuck to my boot for three months once!"

Bill: "NELL!! Get on with the real story!"

Nell: "Ok, so in 1993, the Museum of Fine Arts brought us back to the stage as part of a huge exhibition all about Gus and his artwork. I didn't get to perform, but I was on display in the exhibition."

Bill: "Oh, for Pete's sake! *I'll* tell them! Every Christmastime, the Museum of Fine Arts has free marionette shows for the people of Santa Fe. Mostly, we tell the story of Juan and his burro, Miguelito. Do you know it? Oh it's a charming tale. Let's see, there's Juan and Miguelito and his wife (no, Juan's wife, silly) Rosina and the Duendes (Warts and Freckles) and Doña Mala.

25

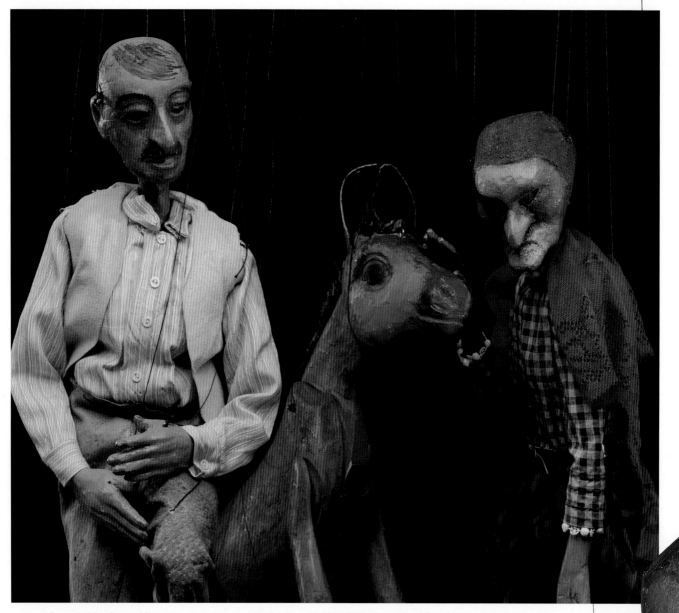

Juan and his Burro, Miguelito, are often troubled by the evil Doña Mala. I wonder what she's up to now.

"Oohh, Doña Mala, she's pretty mean. In fact, she's a witch, and a witch with a big headache: it's December and she hates Christmas. There's nothing worse than a mean witch with a headache! Sheesh! She's even mean to the Duendes (and they *like* her). To make her feel better, Warts and Freckles decide to steal Miguelito from Juan. If they can get the burro to cry, then Doña Mala can use the tears to make a potion to keep Christmas from coming. I won't even tell you all the trouble the Duendes cause, you'll have to imagine it. When they steal the burro, Juan is *very* upset. He and Miguelito are great friends. Here's a scene. Read it and see what I mean":

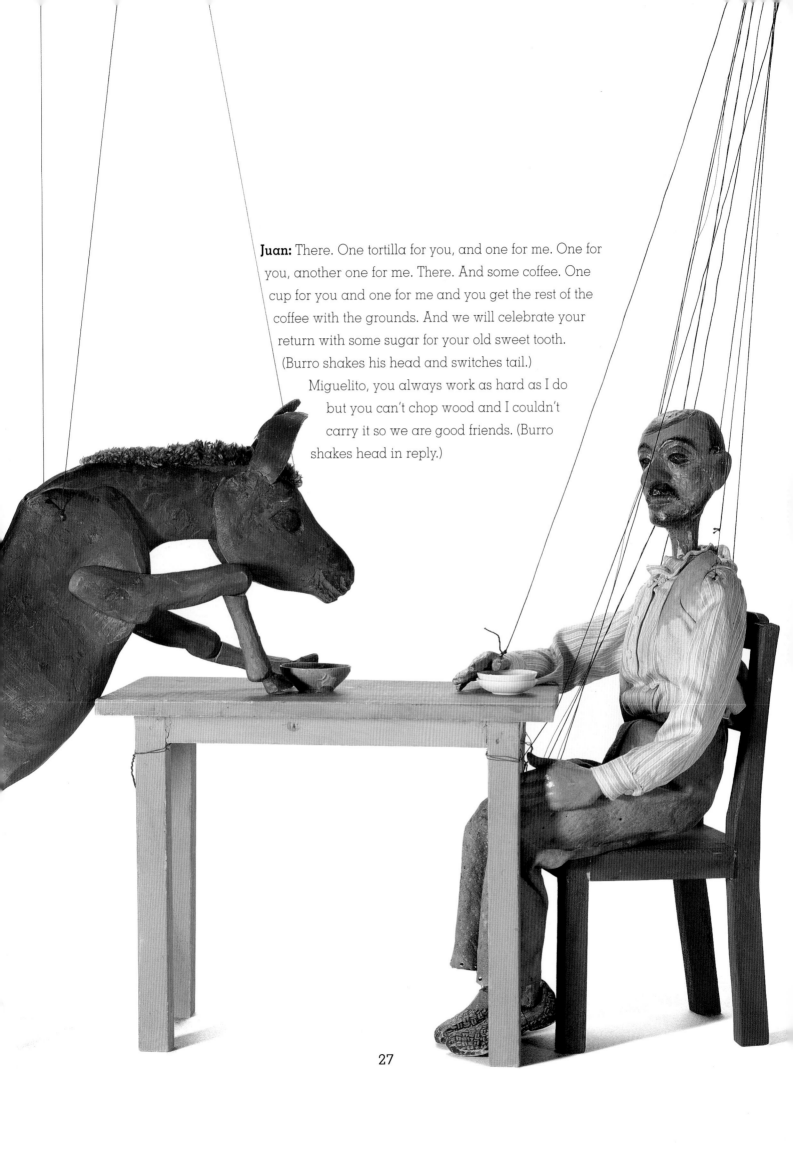

Juan: There. One tortilla for you, and one for me. One for you, another one for me. There. And some coffee. One cup for you and one for me and you get the rest of the coffee with the grounds. And we will celebrate your return with some sugar for your old sweet tooth. (Burro shakes his head and switches tail.)

Miguelito, you always work as hard as I do but you can't chop wood and I couldn't carry it so we are good friends. (Burro shakes head in reply.)

27

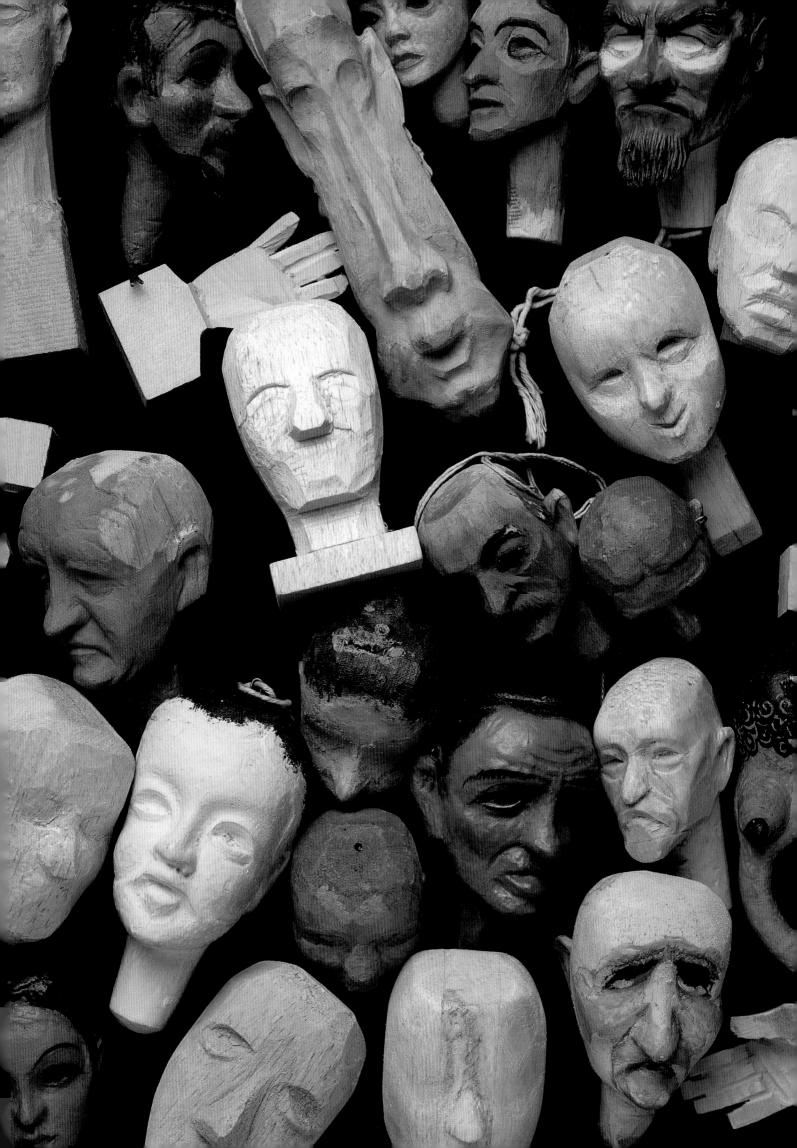

Marionettes, or string puppets, require a special type of stage to hide the puppeteer. Unlike most puppets, marionettes are almost always operated from above. A typical marionette stage has a platform for the puppeteers and a big frame on the front with a small, marionette-sized window that hides puppeteers.

The word "marionette" is used almost always to describe puppets manipulated by strings. The body of the puppet is traditionally, though not necessarily, made of wood. The strings or threads lead from the puppeteer's control, or crutch, to various body parts of the puppet. A common marionette has nine strings—one to each hand, one to each leg, one to each shoulder, one to each ear, and one to the spine—but the strings may number from three to nearly thirty, depending on how many different types of moves you want the puppet to perform. The greater the number of strings, the more difficult the marionette is to operate.

The strings of the marionette are all connected to the controller, or crutch or flyer, as it is known. The puppeteer rocks the controller from side to side to achieve some motion. Baumann's controllers often have a detachable part to move some body parts by themselves. It often requires two hands to operate a moving marionette. Gus's scripts sometimes call for a puppet to sit at a table or weave at a loom or ride a horse!

Gus himself said that making marionettes "is slow business; and what fastidious creatures they are, insisting as they do not only on smooth working joints and flexible innards, but

the right setting as well before they'll feel at home!" In other words, he felt that the puppets demanded that he spend a lot of time and take care making them.

So, if you are trying to make your own marionettes, you have to be really patient! The hardest parts are carving the body parts and stringing the strings. It's probably easiest to buy marionettes made by someone else or a kit with clear instructions. Here's a string diagram from a kit that Gus owned: boy is it confusing!!

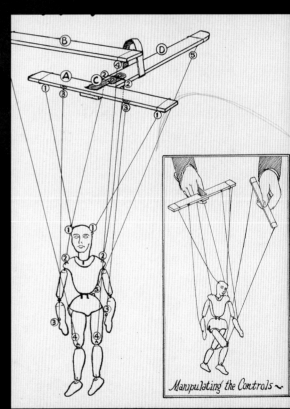

Manipulating the Controls ~

Left: Part of the Museum's collection includes a bunch of marionette spare parts. You might be amazed at all the heads Gus carved. He could have made at least 20 more puppets from the spare parts alone. Above: Gus and Jane kept all their scripts and sketches and notes about marionettes. The Museum keeps them safely near us in big scrapbooks. This is just one of the sheets describing how to make a marionette. Gus had at least three others.

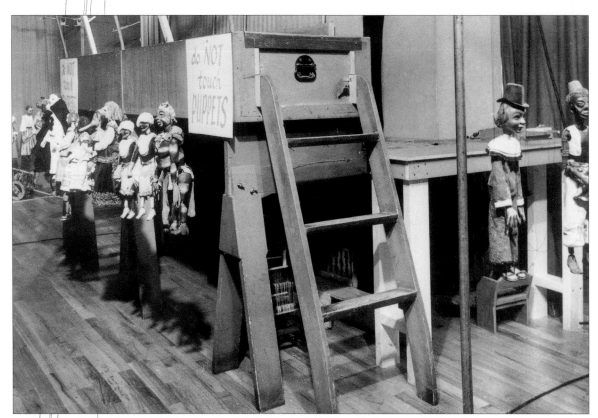

This is a photo of us "hanging around" backstage at the Museum of International Folk Art. As you can see, it's pretty boring waiting for the show to start. The ladder leads to the platform where the puppeteers stand. The signs are meant to keep away people who don't know how to handle puppets. Otherwise our strings get tangled and our clothes get dirty.

WRITING YOUR SCRIPT: Gus said, "It is generally accepted that the backbone of a marionette play is the script, when written with due regard to what can or cannot be presented on a marionette stage."

What he meant was that there is no point in having marionettes perform unless you have a good story and good dialogue (or things for them to say to each other). Gus points out that it is important to remember that marionettes are special, and so you have to write a script especially for them. They are different from sock puppets, muppets, or shadow puppets, for example. Mostly what makes them different is that their hands and feet and heads move. They actually walk on the floor and sit down on things, because the puppeteers are above the stage.

There are some key things to consider when writing a marrionette script: What is the main idea of the story? Where does it take place? Who is it about? What happens first in the story? How does it end? How many scenes are there? How many puppets do you have? How many puppeteers do you need?

(Remember, a puppeteer only has two hands, and some moves require both hands on one puppet.)

Quack!

Professional marionette groups spend a lot of time making sure their stage is properly lit before the performance, since a misplaced light can make the puppeteers cast shadows. No one wants the audience to be looking at shadows or to see the puppeteers, so it is important to have enough light on the marionettes and none on the puppeteers.

REHEARSALS ARE IMPORTANT: For a performance of *Juan Y Burro*, Los Titiriteros rehearse for about three weeks! They begin by going over the script and making sure everyone knows what their marionettes will be doing. As Gus warned, "If your part is fairly difficult, do not be dismayed if you cannot master it at once." This is good advice, and the puppeteers take it to heart. Sometimes they spend a whole day practicing one scene. Once they are sure they know what their marionettes are going to say to each other, the puppeteers have to decide where the marionettes will stand and move in each scene. This is called staging, or blocking, the scene.

Because of the way a marionette is built, you cannot rely on a smile or wink or frown to indicate how your marionette feels. You have to use other body language, such as moving hands to show excitement or kicking the ground to show frustration. Also, there are a few things that no matter what, a marionette will not do. Gus says, "It cannot pass through a door or pick up things and lay them down without the aid of trick devices. At the same time it can, if occasion requires, do surprising things the human actor does not do readily." For example, marionettes can fly, jump really high, and collapse in a heap on the floor.

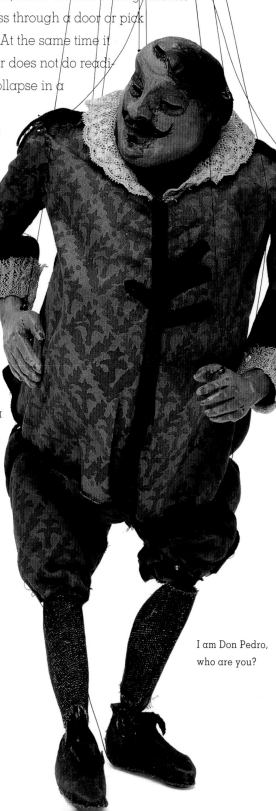

Gus's final piece of advice is that "Good marionettes have a distinct personality and like good actors they are temperamental; letting them express it in their particular way will reward you with a performance on which the curtain can safely be raised to an appreciative audience." This means that good puppeteers spend a lot of time getting to know their marionettes. They pay close attention to how their arms and legs move and what direction their heads tend to point or lean.

GET TO KNOW YOUR PUPPET: Once they have a good understanding of how the marionette gestures and stands—Does it slouch? Is its belly large and sticking out? Do they keep their hands on their hips?—next they have to give the marionette a voice. This can be the hardest part of the whole performance. The wrong voice can ruin a marionette show. Imagine if the voice a puppeteer plays is really annoying and hard to listen to. The audience will hate the show. Big male characters often have loud, deep voices. And pretty female puppets frequently have softer, gentler voices.

If the play is a comedy, the actors sometimes give the characters funny voices (like the big, fat Don Pedro might have a thin, high voice, and the Tourist Lady might have a loud, deep, booming voice).

I am Don Pedro, who are you?

31

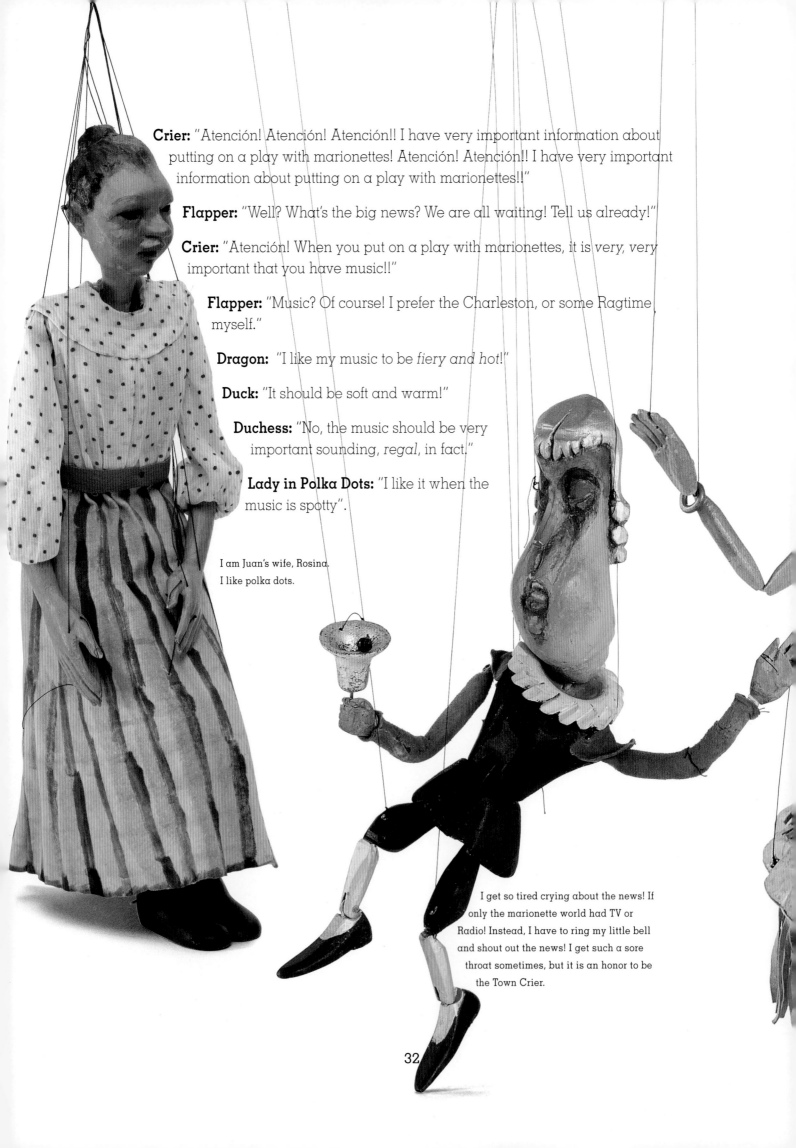

Crier: "Atención! Atención! Atención!! I have very important information about putting on a play with marionettes! Atención! Atención!! I have very important information about putting on a play with marionettes!!"

Flapper: "Well? What's the big news? We are all waiting! Tell us already!"

Crier: "Atención! When you put on a play with marionettes, it is very, very important that you have music!!"

Flapper: "Music? Of course! I prefer the Charleston, or some Ragtime myself."

Dragon: "I like my music to be *fiery and hot!*"

Duck: "It should be soft and warm!"

Duchess: "No, the music should be very important sounding, *regal*, in fact."

Lady in Polka Dots: "I like it when the music is spotty".

I am Juan's wife, Rosina.
I like polka dots.

I get so tired crying about the news! If only the marionette world had TV or Radio! Instead, I have to ring my little bell and shout out the news! I get such a sore throat sometimes, but it is an honor to be the Town Crier.

32

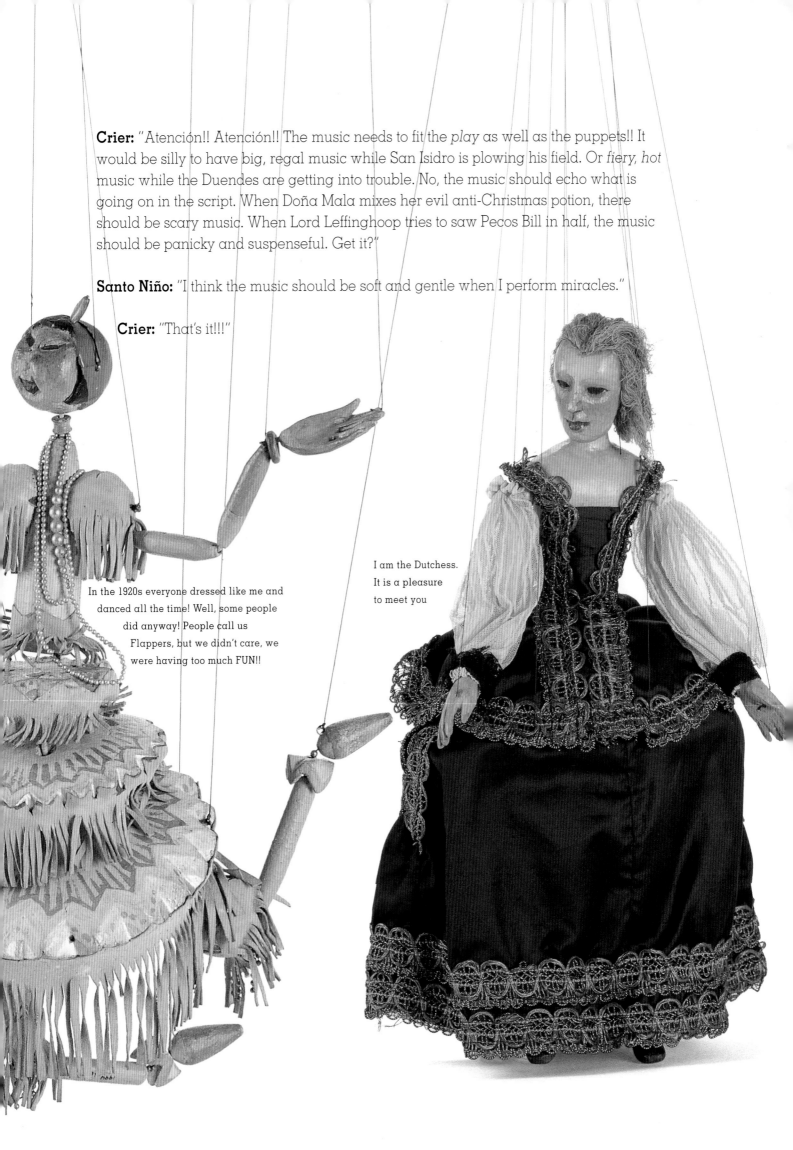

Crier: "Atención!! Atención!! The music needs to fit the *play* as well as the puppets!! It would be silly to have big, regal music while San Isidro is plowing his field. Or *fiery, hot* music while the Duendes are getting into trouble. No, the music should echo what is going on in the script. When Doña Mala mixes her evil anti-Christmas potion, there should be scary music. When Lord Leffinghoop tries to saw Pecos Bill in half, the music should be panicky and suspenseful. Get it?"

Santo Niño: "I think the music should be soft and gentle when I perform miracles."

Crier: "That's it!!!"

In the 1920s everyone dressed like me and danced all the time! Well, some people did anyway! People call us Flappers, but we didn't care, we were having too much FUN!!

I am the Dutchess. It is a pleasure to meet you

How Did Gus Do It?

How did Gus make all his puppets? That is a terrific question. We may never know exactly, but some clues may be found in the spare parts that he left behind. We also have some of his sketches, which Gus probably used as patterns for his marionettes. Mostly, it seems he carved the feet, hands, calves, thighs, forearms, upper arms, torso, and head all as separate parts. Then he used a complicated and detailed series of joints to connect each limb where it belongs. The strings are mainly connected to the head, hands, and knees, although certain puppets have more elaborate strings.

We know that Gus thought a lot about who the puppets were as he made each one. Some puppets could be used in many different scripts, because they are general characters (a man, a woman, a duck or donkey). Some puppets were specific characters, and although they may appear in different plays, they always play the same character (Santa Claus, Santo Niño, Warts, Freckles).

And some puppets were so special they only performed in one play. For example, the Eagle Dancers, Koshare, and Indian Drummer were all designed specifically to perform Native American dance movements in time to Native American music. When he made the Koshare marionette, Gus was helped by a man from San Ildefonso Pueblo who was a well-known Koshare.

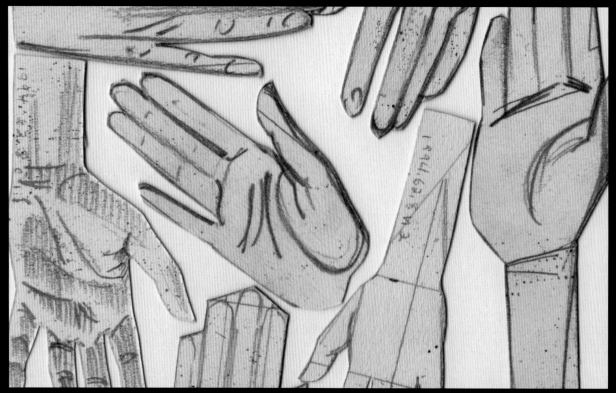

These cardboard hands were used as models for the puppet hands Gus carved out of wood.

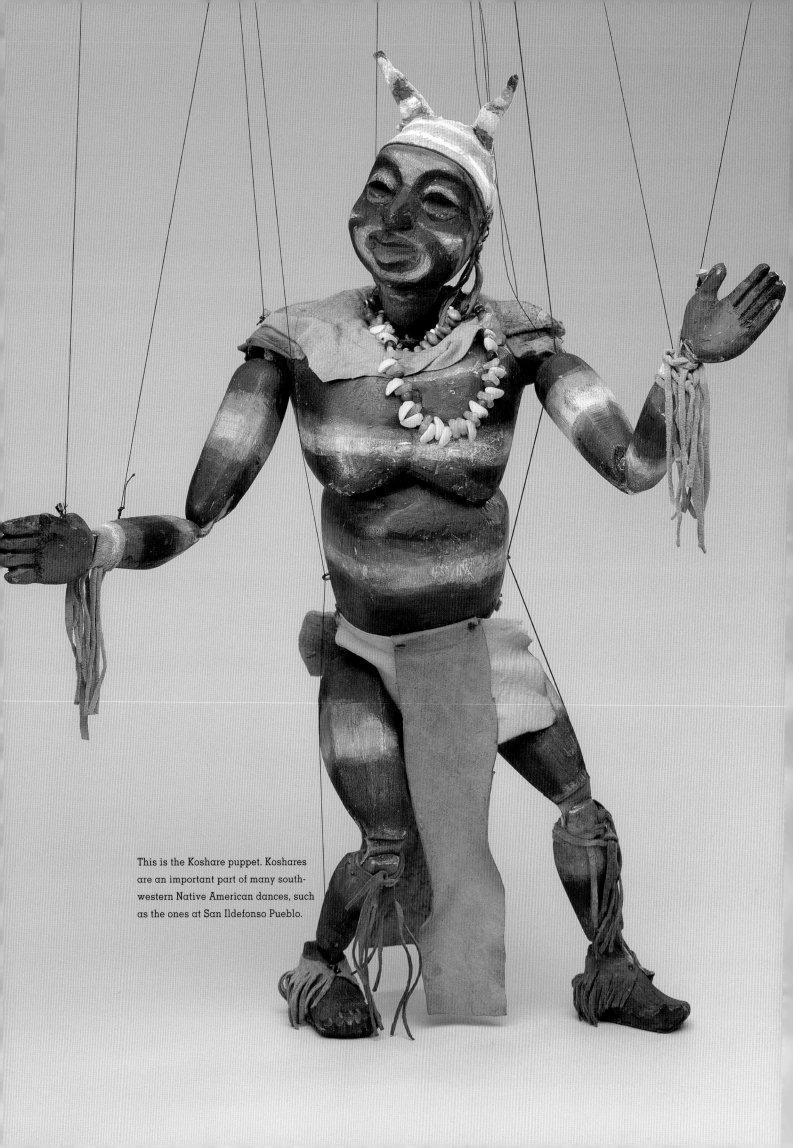

This is the Koshare puppet. Koshares are an important part of many southwestern Native American dances, such as the ones at San Ildefonso Pueblo.

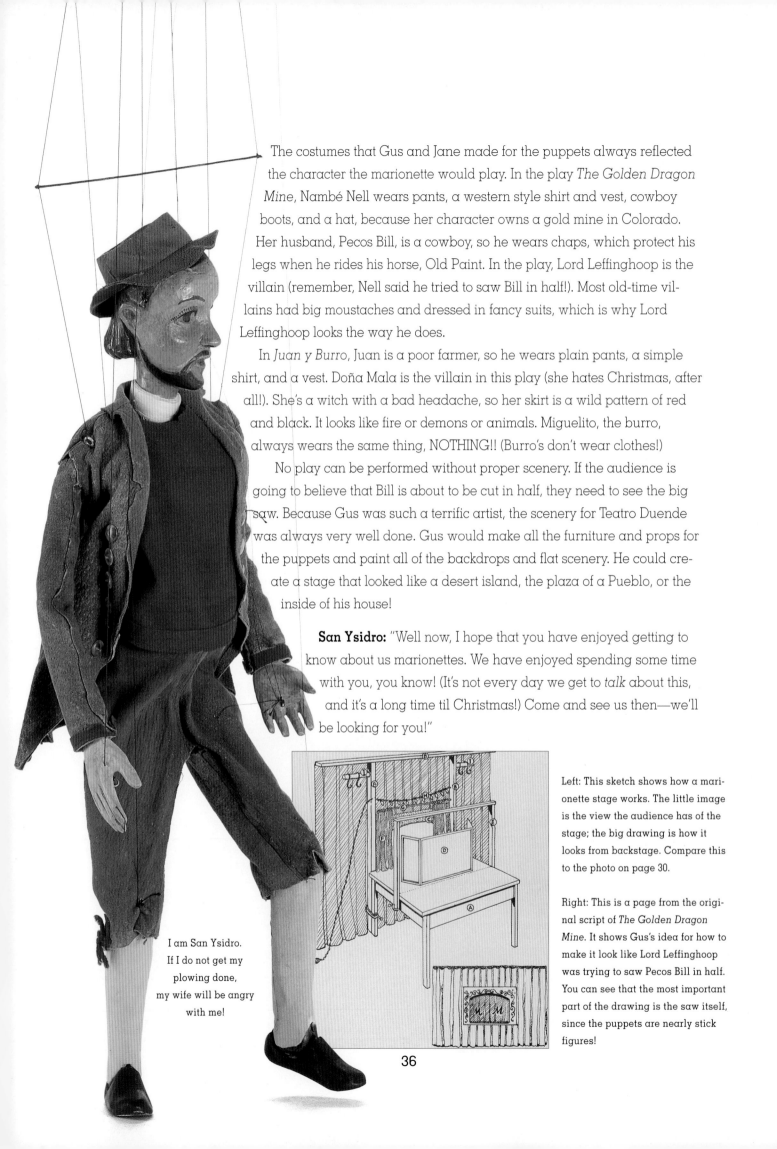

The costumes that Gus and Jane made for the puppets always reflected the character the marionette would play. In the play *The Golden Dragon Mine*, Nambé Nell wears pants, a western style shirt and vest, cowboy boots, and a hat, because her character owns a gold mine in Colorado. Her husband, Pecos Bill, is a cowboy, so he wears chaps, which protect his legs when he rides his horse, Old Paint. In the play, Lord Leffinghoop is the villain (remember, Nell said he tried to saw Bill in half!). Most old-time villains had big moustaches and dressed in fancy suits, which is why Lord Leffinghoop looks the way he does.

In *Juan y Burro*, Juan is a poor farmer, so he wears plain pants, a simple shirt, and a vest. Doña Mala is the villain in this play (she hates Christmas, after all!). She's a witch with a bad headache, so her skirt is a wild pattern of red and black. It looks like fire or demons or animals. Miguelito, the burro, always wears the same thing, NOTHING!! (Burro's don't wear clothes!)

No play can be performed without proper scenery. If the audience is going to believe that Bill is about to be cut in half, they need to see the big saw. Because Gus was such a terrific artist, the scenery for Teatro Duende was always very well done. Gus would make all the furniture and props for the puppets and paint all of the backdrops and flat scenery. He could create a stage that looked like a desert island, the plaza of a Pueblo, or the inside of his house!

San Ysidro: "Well now, I hope that you have enjoyed getting to know about us marionettes. We have enjoyed spending some time with you, you know! (It's not every day we get to *talk* about this, and it's a long time til Christmas!) Come and see us then—we'll be looking for you!"

I am San Ysidro. If I do not get my plowing done, my wife will be angry with me!

Left: This sketch shows how a marionette stage works. The little image is the view the audience has of the stage; the big drawing is how it looks from backstage. Compare this to the photo on page 30.

Right: This is a page from the original script of *The Golden Dragon Mine*. It shows Gus's idea for how to make it look like Lord Leffinghoop was trying to saw Pecos Bill in half. You can see that the most important part of the drawing is the saw itself, since the puppets are nearly stick figures!

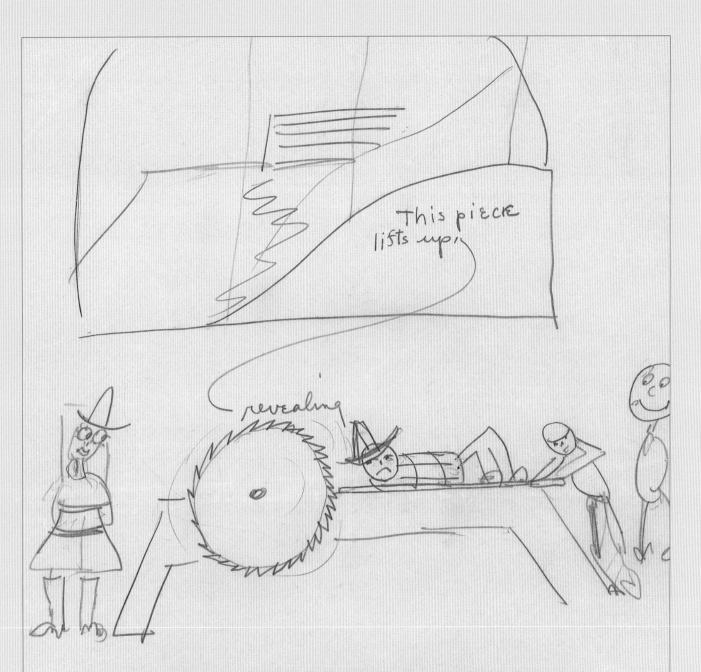

doing the dirty work, and Lord Leffinghoop is standing beside him.
The dragon must get off the stage first. Let him beat on the hillside
three times with his tail and go back to the cave. Then the Old man
of the Mountains can say:

 Snorum, Snorum,
 Buzz-saw gore!
 Lift up hill!
 Show us some more!

As soon as the hill is XXIZX We see Hardpan pushing Bill a little
closer to the saw each time.

 NELL
Save him!

 LORD L.
 Saw him!

Gus on the Couch

Gus carved three marionettes to represent his family and wrote a play about their life at home.

(Gus lying on couch, animated slightly as if asleep and restless. Old Man of the Mountains enters, looks about, walks around, tries to waken Gus by tapping on his head. Clock strikes two, Old Man of the Mountains jumps on Gus's chest twice and flies off stage.)

Gus (wakens): Oh these marionettes they follow me even in my sleep .Well, out to the studio here it is two o'clock. (Ann enters skipping, sits beside Gus.)

Ann: Da, where do horny toads sleep?

Gus: Under this couch.

Ann (gets down to look under): No, I don't see any.

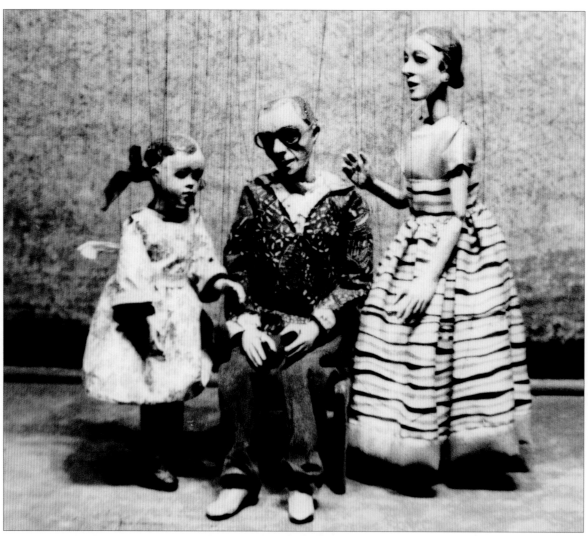

Ann, Gus, and Jane Baumann puppets, Collection Museum of Fine Arts.

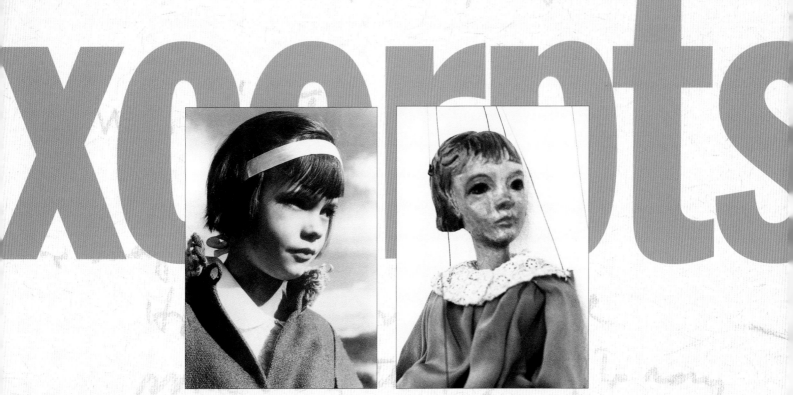

Ann, age ten, and the marionette her father carved. Baumann family puppets and these photos courtesy of Ann Baumann.

Gus: Has it got horned-rimmed pyjamas?

Ann: Oh, Da!

Gus: Has it got ants in its pants?

Ann: No, I don't see any horny toad at all, but I saw one this morning in the yard and it didn't have a thing on but horns!

Gus: Oh Ann, that won't do. Tell your mother she must sew something for the toady right away. And now I have to go out to the studio.

Ann: Da, why do you go out to the studio?

Gus: There are a lot of patients out there whose joints won't work, back-strings are twisted and one of them lost his head!

Ann: When you lose your head, can I look inside?

Gus: Sure, you'll see many things, but never mind.
(Jane calls off)

Jane: Oh Ann!

Gus: Saved again, and now I can go. Ann ask your mother if we can have popovers tonight.
(Gus exits, door slams.)

Santo Niño

Freckles and Warts are some of the many *Duendes* that Gus created. The Duendes are like elves, only they usually cause trouble rather than help people. In the play *Santo Niño*, Juan and his wife Rosina have to finish a rug and pair of shoes before morning. They are very busy trying to complete their work when they are visited by the Duendes. Here is part of the script so you can see for yourself what pests they can be:

Freckles: You hear that? They have so much to do.

Warts: And so little time.

Freckles: How can we pester them?

Warts: He is doing holy work, making shoes for Santo Niño—and he could drive us away.

Freckles: Then let's get rid of him.

Warts: How?

I am Santo Niño, I come
to help people who are good
and kind to me. I help so many
people that I often wear out my shoes.
Do you have new shoes for me?

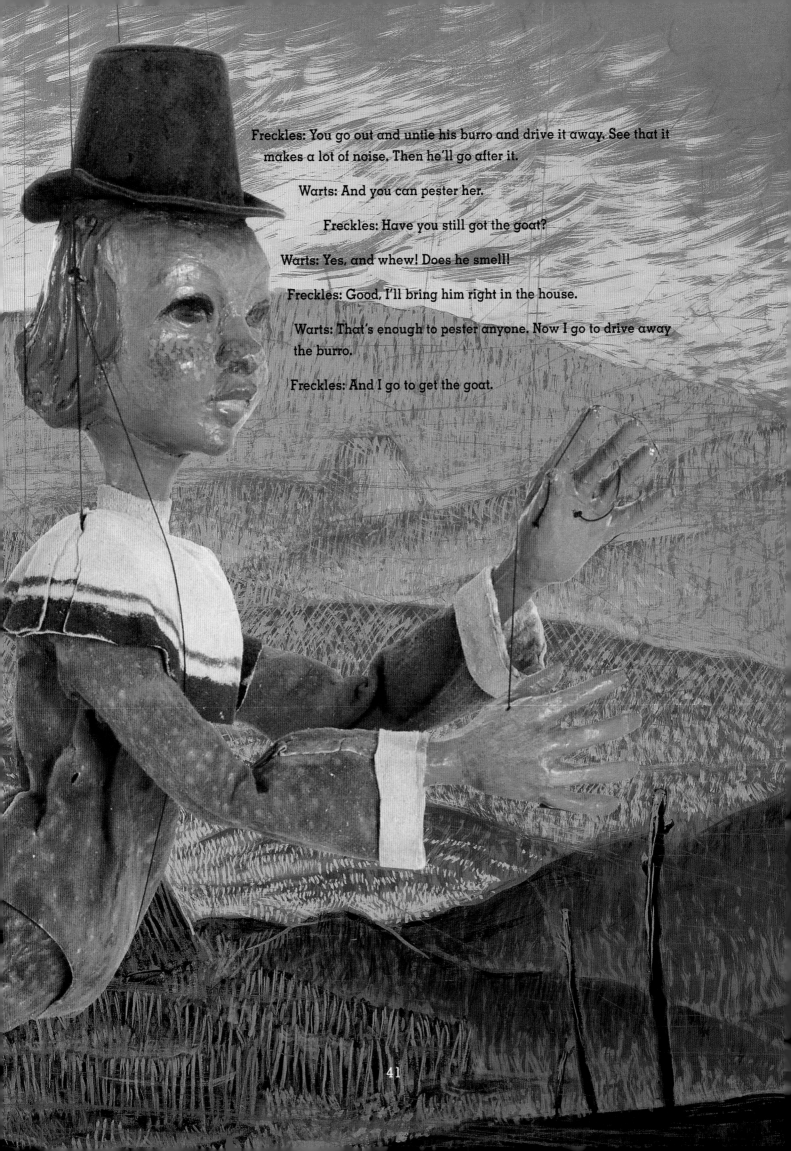

Freckles: You go out and untie his burro and drive it away. See that it makes a lot of noise. Then he'll go after it.

Warts: And you can pester her.

Freckles: Have you still got the goat?

Warts: Yes, and whew! Does he smell!

Freckles: Good, I'll bring him right in the house.

Warts: That's enough to pester anyone. Now I go to drive away the burro.

Freckles: And I go to get the goat.

Is It Not Monstrous?

Sometimes Gus and Jane used puppets that were common to New Mexico life (like the Eagle Dancers, Nambé Nell, and the Tourist), and sometimes they used characters that were common to puppetry itself. Some of the earliest puppet characters (which were developed in France and Italy) were clowns named Pierrot and the Harlequin. They were very silly characters and very well known. The play *Is It Not Monstrous?* uses these characters and a live, human actor. It is very silly, as you should be able to tell from these two scenes:

Pierrot: Why did the cook say she wanted to give you spelling lessons?

Harlequin: She's a silly old fool. And you're an ignoramus. Tell me now, if you can, what is the moon?

Pierrot: It's a big cheese.

Harlequin: A cheese. Oh, your ignorance will kill me. I'll die of shame.

Pierrot: Well, then, what is it?

Harlequin: It's a balloon.

Pierrot: Have you been up there to see?

Harlequin: No, Imbecile. But it's easy to understand. A cheese can't float in the air . . . while a balloon . . .

Pierrot: All right. Do you know why the moon shines at night?

Harlequin: And you, I suppose you know?

Pierrot: Yes, it is full of lightning bugs getting their supper.

Harlequin: It's a balloon I tell you. Ah, if I could only find some wise and honest professor for you who could infiltrate his science into that thick spongy head of yours. . . .

(Soon a member of the audience steps up to the stage and interrupts Pierrot and Harlequin.)

Actor: By God! I've got it! I've got it! Look here my little fellows, I've a brilliant idea, a magnificent proposition—

I am Harlequin. I am forced to spend time with that ignorant clown over there!

42

Harlequin: . . . this distinguished audience?

Actor: But, my very dear little fellows, you don't understand. I have a unique proposition to make. You see, I—

Harlequin: In the midst of a performance?

Actor: But this is something extraordinary, something absolutely and entirely—

Harlequin: Who you are?

Actor: (with exaggerated courtesy): O, I beg pardon. Let me give you my card. (Hold it while they look at it.)

Harlequin (laughing): Yes, isn't it?

Actor (Sorely irritated): May I ask what is the inspiration for all this mirth?

Pierrot: It's so funny.

Actor: But really! Now then, my proposition—

Harlequin: We must resume our performance. (They repeat the last lines before the Actor interrupted them)

Actor (talking right along with them): You see, for a long time it was my dearest ambition to do something really unique in the theater AND tonight while watching your performance, the inspiration finally flashed through my brain: I shall give a dramatized version of "The Selfish Giant." I shall play the giant and all of the other characters of the play will be portrayed by puppets and for that purpose I shall engage you and your colleagues. How's that for a spectacular vehicle? Eh? How's that for the chance of your careers? Well, what do you say?

Harlequin: We can't!

Actor: But I don't understand. Why? WHY? Don't you realize what a unique privilege this would be for you and your associates? Imagine, mere little dolls acting together on the stage with a distinguished human actor. What a chance to demonstrate the puppet's ability to simulate human personality. Why, it will inaugurate a new era in the theater, think of it!

Harlequin: That may well be, but we can't. Come Pierrot.

My name is Pierrot, and I am pleased to meet your acquaintance. Have you met my annoying friend, the Harlequin?

43

Actor: But, but—is it, is it, now I want you to be quite frank with me, is it, er, modesty? Are you perhaps afraid that you and your little colleagues could not meet the severe test of appearing side by side on a stage with a human actor? Be quite frank.

Harlequin: Nope, that's not it.

Actor: Well, what, then?

Harlequin: This interruption must stop

Actor: But, my God, I'm at least entitled to a—

Harlequin: Dilettante

Actor (storms): What? Well of all the colossal impudence. I've a good notion to—(raises an arm menacingly)

Harlequin: I am quite insensible to pain, you know.

Actor: Dilettante! Don't you know that I am one of the most famous and highly paid actors in America?

Harlequin: That's just it!

Actor: Just what?

Harlequin: You're an actor!

Actor: Yes, and—

Harlequin: Well, that makes you a dilettante.

Actor: You've trifled with me long enough, do you hear? Why I've a good notion to—(thrusts his hand into the lighted stage with clutching gesture, but misses Harlequin who has quickly stepped aside and off left). Darn it!!

This photograph from the Baumann scrapbooks is probably a scene from the play *Birthday of the Infanta*, written by Oscar Wilde.

Excuse me! I am not from around here. Can you perhaps tell me where the restroom is?

44

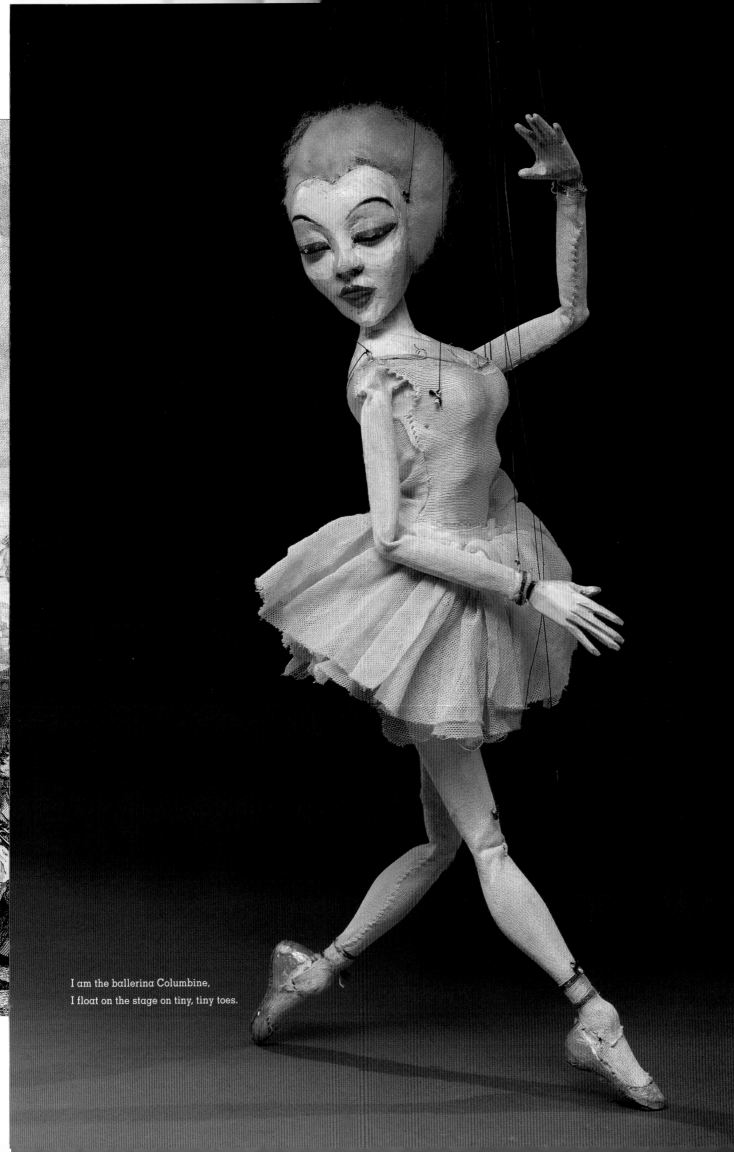

I am the ballerina Columbine,
I float on the stage on tiny, tiny toes.

laboration among talented theater people, playwrights, musicians, painters, and sculptors, he created the modern artistic puppet theater.

This transformation in the art of puppet theater soon influenced puppet theaters throughout Europe and ultimately in the United States (Till 1986; Dering 1988). Centuries before the arrival of puppets from Europe, America had its own native puppet tradition, expressed in the ceremonial life of diverse Native American tribes. In the Southwest, the Pueblo Indians at Hopi and Zuni created kachinas, masked figures animated by human actors, to enact ancient rituals. The practice continues uninterrupted to this day.

Puppetry's long tradition in Spain came to the New World with the Conquest, arriving in Mexico some two hundred years before English puppets reached the Colonies. The first puppets in the American Southwest arrived via the Camino Real with the first Spanish colonizers who brought mystery and morality plays and pageantry. Itinerant theater entertainers were a tradition in New Mexico well into the first decades of the twentieth century.

The new artistic style from the Western puppetry tradition began in the U.S. with Ellen Van Volkenburg's puppet theater of Chicago. Traveling in Europe she procured some examples of Josef Schmid's puppets and returned to America full of ideas about modern puppetry. Her 1916 production of Shakespeare's *A Midsummer Night's Dream* at the Chicago Little Theater announced the American Puppetry Revival Movement and launched a new era of artistic puppetry.

The leader proper of the revival movement was the legendary impresario Tony Sarg. In 1917 Paul Brann's Munich Artists Marionette Theater was scheduled for a run on Broadway in New York. Complications of the war forced the producer instead to hire Tony Sarg. Sarg mounted Franz Pocci's *The Three Wishes* from Schmid's repertory, a successful debut that began a long career of marionette plays in New York and touring companies across the United States. Sarg's repertory included plays based on literary classics such as *Treasure Island* and *Alice in Wonderland*, performed to artistic standards equal to those found in German puppetry theater of the era.

In 1929, the Tony Sarg Marionettes traveled to Santa Fe, New Mexico, for a performance at the Museum of Fine Arts. Gustave Baumann was in the audience, and he would later write that the experience "aroused my interest which had lain dormant since my student days abroad" (Baumann 1959).

Other stars of the revival movement included Sue Hastings, a Sarg protégé, Remo Bufano, a great showman who authored numerous books on the puppetry art, and Paul McPharlin. In 1930 McPharlin established a fellowship to train young puppeteers and in 1936 organized the first national puppet conference, from which The Puppeteers of America was formed. McPharlin also organized the first national exhibition to showcase some of the best puppeteers in the United States. They appeared at the 1933 Chicago World's Fair. The list of these important puppeteers included Tony Sarg and Remo Bufano from New York City and Gustave Baumann from Santa Fe, New Mexico (McPharlin 1969).

Baumann's interest in puppetry began with his childhood in Magdeburg, Germany, where he spent his first ten years. At the time, the Schichtl and Schwiegerling puppet theaters resided in Magdeburg (Tyroller 1999) and performed at the Domplatz, or cathedral square, during festivals and at fairs. In 1891 Baumann's family moved to Chicago, which two years later hosted the Columbian Exposition to celebrate the 400th anniversary of Columbus's landing in America. There the young Baumann saw shadow puppets from Java and performances by some of the greats in American puppet theater of the period.

"Papa Schmid with Casperl Larifari, his most famous marionette. Papa Schmid influenced Baumann and many other European and American puppeteers." Courtesy of the Puppet Theater Museum Collection, City Museum of Munich, Munich, Germany.

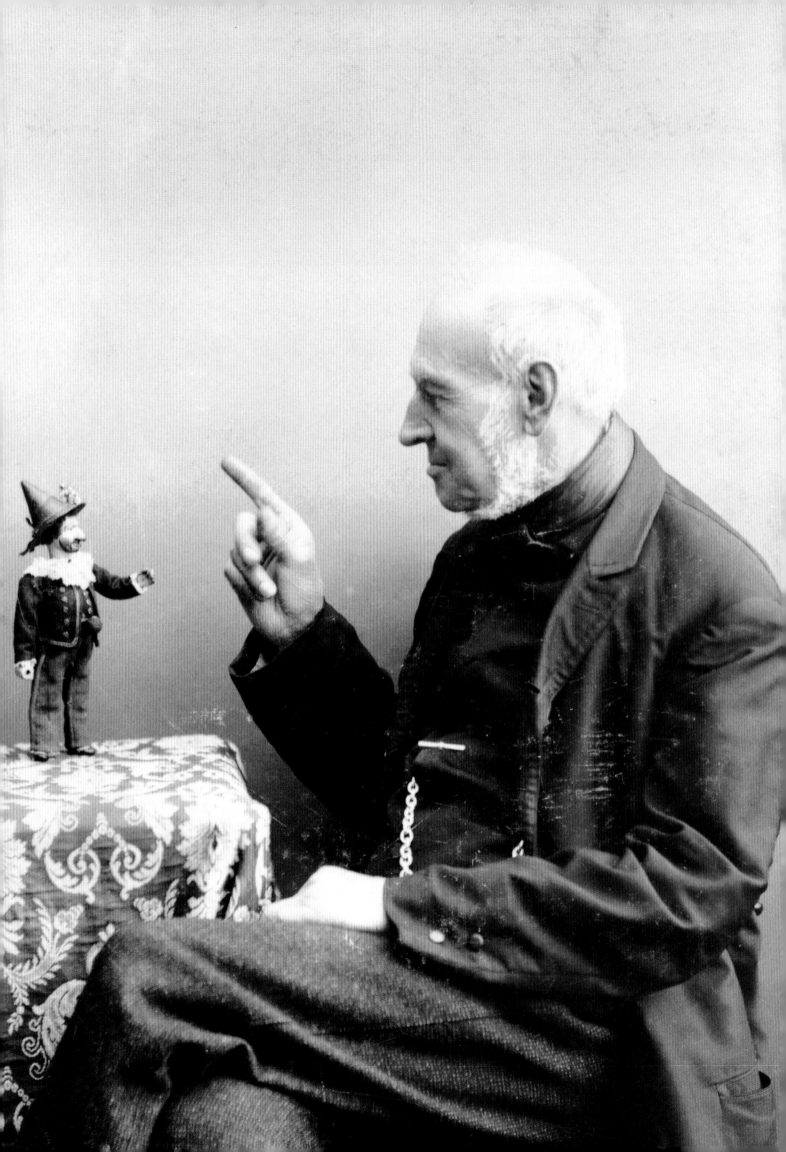

In 1905, Gustave Baumann returned to Germany to study art at Munich's Royal School of Arts and Crafts. There a second opportunity to see German puppet theater presented itself. Courses at the school included fine arts, architecture, decorative arts, and furniture making. Baumann studied printmaking and wood carving, developing skills that served him throughout a lifelong career in the arts. While in Munich he carved out of wood an entire toy village, fashioning people, shops, churches, houses, trees, and effects to bring a storybook mountain village to life. During his year abroad, Baumann possibly attended rehearsals of Paul Brann's marionette theater and saw Papa Schmid's 1905 Munich season.

After his return to Chicago in 1906, Baumann received immediate recognition for his Munich work, winning an award for his miniature toy village at the Art Institute of Chicago. Although his main focus remained on printmaking, Baumann continued to create wood sculpture. During summers at the art colony in Brown County, Indiana, he made marionettes that parodied the Hoosiers (the nickname for the people of Indiana), and in 1917 he taught toy making at a summer school in Wyoming, New York.

In the summer of 1918 Baumann traveled to the art colony of Taos, New Mexico, on the advice of fellow artists Walter Ufer and Victor Higgins, with whom he had studied at the Art Institute. From there he journeyed to Santa Fe for an exhibition of his color woodcut prints at the Museum of Fine Arts. Intending to stay only a short time, he met the museum's curator, the German-born Paul Walter, and instead was convinced to settle in Santa Fe. He remained a resident throughout his life.

Although he spent a lot of time making and selling his prints, Baumann played an active role in Santa Fe's cultural life from the outset. In 1918 he met Mary Austin, a writer who had helped found a

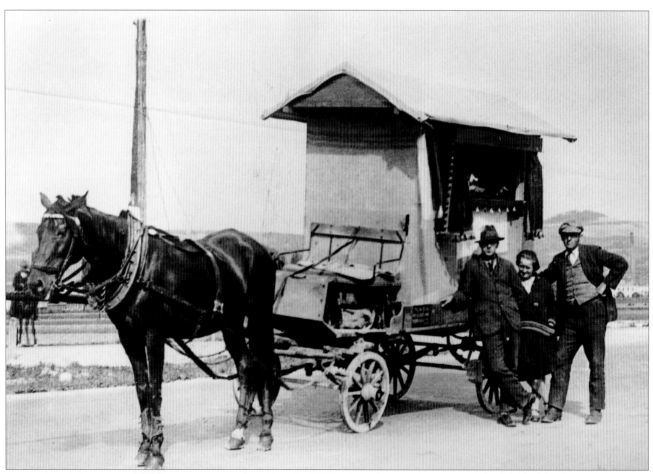

Traveling Hand Puppet Troupe, circa 1910. Photo by Netzle. Courtesy of the Puppet Theater Museum, Collection of the City Museum of Munich, Munich, Germany.

community theater in the California art colony of Carmel. When Mary Austin decided that Santa Fe needed a theater, Baumann helped her with it. He painted scenery, designed sets, and directed the theater's first play in 1919.

From the moment he arrived, Baumann had an interest in the culture and landscape of northern New Mexico. He explored the prehistory of the ancient people and attended ceremonies of the Pueblo Indian people who had lived there for hundreds of years. On Christmas Eve in 1923, Baumann attended the religious dance at the San Felipe Pueblo. There he met Jane Henderson, a young actress and singer from Denver, Colorado, and the two married in 1925 (Acton 1993).

Jane played an important role in Baumann's life. She handled the public relations for his business and she entertained clients and sold prints. She also helped him with his puppet theater. Before she came to New Mexico, she had studied in Paris and enjoyed an acting career in London and Denver. To Jane the puppet theater was "the essence of theater, all the elements of drama packed into the special small world of the marionette stage" (*Puppetry Journal* 1959). With his marriage to Jane, Baumann now had all of the basics he needed to start his own puppet theater. He knew how to carve marionettes and to design and paint sets and direct plays. Jane's acting experience and her speaking voice completed the skills Baumann needed for his theater.

The Baumann puppet theater focused primarily on plays about New Mexico and the West. Many of the marionettes Gustave carved represented the native New Mexican and Pueblo Indian people, as well as characters from the Wild West. He also included a few dramatic plays based on the classics and some featuring the *commedia dell'arte* characters Pierrot, Columbine, and Harlequin. He worked with local writers, such as Raymond Otis, who wrote for him the play *Tia Sucia*, and began writing his own plays for the enjoyment of adults and children alike.

The Marionettes Backstage, ca. 1935. Color woodcut by Gustave Baumann. Collection Museum of Fine Arts.

Having raised several batches, more or less successfully, we find that marionettes are the ever new problem-children who with their pleasantly unpredictable behavior have taught us how to make a virtue out of their limitations. If a script written for them is too cumbersome, they ignore it as unplayable and suggest their own way of rewriting it, which the sensitive puppeteer at the control ends of the strings usually finds it expedient to abide by (Baumann 1959).

Between 1929 and 1933 Baumann carved enough marionettes to begin mounting productions. In 1931 he traveled to Hollywood to consult with Forman Brown of the Yale Puppeteers. Brown wrote humorous plays based on folk tales and dramas. While Baumann was visiting, the Yale Puppeteers performed one of Brown's plays, *Caesar Julius*, a spoof on William Shakespeare's serious play (McPharlin 1969). From his time spent with Brown and the Yale Puppeteers, Baumann learned some important lessons about the puppet theater business and performance.

Baumann showed his marionettes for the first time at the 1932 Santa Fe Spanish Arts Festival, at

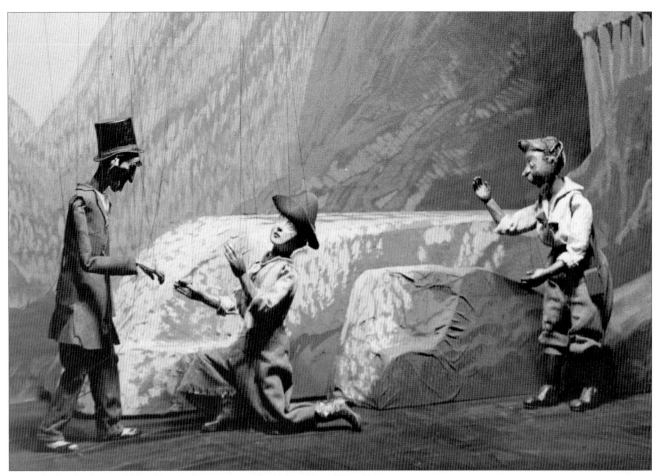

The Golden Dragon Mine, from the Baumann notebooks, Museum of Fine Arts.

the invitation of organizer Mary Austin. That Christmas, a tradition began of puppet theater at the Baumann home for daughter Ann and family friends. The performance typically was introduced by the Eagle Dancers and the Indian Drummer, marionettes inspired by Pueblo ritual, followed by one or two skits and a short play. Everyone would then pile into cars and drive to San Felipe Pueblo to attend the ceremonial Christmas dances.

In 1933 Baumann's puppet theater, called the Santa Fe Puppet Wranglers, received invitations to exhibit and perform outside Santa Fe. The year seemed promising for Baumann's new puppet theater. Paul McPharlin invited him to exhibit at the 1933 Chicago World's Fair, joining an exhibition of nineteen of America's best-known puppeteers. Baumann's marionettes were shown later at the Cincinnati Art Museum. Thousands saw his marionettes and critics praised them. Success seemed guaranteed.

In the spring of 1933, the Puppet Wranglers were invited to perform in Colorado during the summer opera season in Central City. Colorado poet Thomas Hornsby Ferril wrote *The Golden Dragon Mine* especially for this performance. The play was a humorous melodrama in rhyme about a villain who wants to marry the heroine and take away her land and gold mine and about the hero who saves her (with a little help from Old Paint, his horse, and other characters). Baumann carved the characters for the play: Nambé Nell, the heroine; Pecos Bill, the hero; Lord Leffinghoop, the villain; Hardpan and Temperance, the miners; Lulu, the tourist lady; the Old Man of the Mountain; and the Dragon.

The Puppet Wranglers found a place to set up the stage in an old abandoned store and made seats out of pine planks nailed to wooden barrels. The premiere of *The Golden Dragon Mine* was an uproarious success. Lulu, the fat tourist lady wear-

ing knickers and a green eyeshade, stole the show in the first act. The audience howled with laughter at the lady in "distress"—she couldn't find a bathroom anywhere in town!

The Baumanns' show, ironically, was too successful. The famous New York stage designer Robert Edmond Jones couldn't bear the fact that the marionettes might get more attention than his production of *The Merry Widow* that simultaneously was playing at the Central City Opera. So he demanded that the puppet show had to go. Jones prevailed, and the puppet theater, which had begun with such promise, ended in disaster. Discouraged, the Baumanns packed up the marionettes and returned to Santa Fe (*The Rocky Mountain Herald* 1971).

In 1941 the Baumanns gave two more public performances, one in Albuquerque at the Sandia School where Ann was a student. The Museum of Fine Arts booked the Santa Fe Puppet Wranglers for holiday performances throughout the month of December, but in a profession where timing is everything, timing was once again against them. The Baumanns planned to perform three short sketches and one play. Three days before their opening performance, the Japanese bombed Pearl Harbor, and the United States entered World War II. Although critics praised their performances, the country was preoccupied with the war and audiences were sparse.

> *Baumann, who is one of the line of true puppeteers in the tradition of Father Gepetto, has carved the most delightful puppets I have ever seen, bar none, and graces his stage with beautifully painted sets, each one of which is a tableau full of beautiful color and romantic mood.*
> —*The New Mexican, June 21, 1959*

In 1959 the Baumanns brought the marionettes out for the final performance of their puppet theater, now called *Teatro Duende* (or "Theater of the Little People"), at Santa Fe's Museum of International Folk Art. They hadn't made a public appearance in nearly twenty years, so they again asked for assistance from established professional puppeteers.

Baumann wrote to Martin Stevens asking the famous puppeteer if he would assist them as stage director. Stevens's theater toured all over the United States, and his puppets appeared in films. He arrived in Santa Fe the first part of May to help Jane rehearse the puppeteers for six weeks before the June performances began (*Albuquerque Journal* 1959). For the production, Baumann collaborated with composer and musician Lawrence Powell, who composed a musical score for the play *The Canticle of the Sun by St. Francis*, which celebrated Santa Fe's patron saint of animals and ecology.

Teatro Duende also performed classic drama with a version of Oscar Wilde's play *Birthday of the Infanta*. Baumann's characters included the Infanta (a Spanish Princess) and her Attendant; her father, Don Pedro; his wife, the Duenna; the Hunchback; and a Donkey. The story tells of the celebration of a Spanish princess's twelfth birthday. One of her presents is a "toy," a hunchback dwarf. The Infanta is cruel to him and commands him to dance. At the end of the play, the vain dwarf looks in the mirror and sees a monster. The play ends in tragedy when he realizes that the face in the mirror is his own.

The performance at the Museum of International Folk Art opened on June 8, 1959. Under the direction of Martin Stevens, the puppeteers' long rehearsals and hard work made the final performance of Teatro Duende a resounding success. The Baumann puppet theater played for the next two weeks to enthusiastic audiences and capacity crowds. Their performing career ended on a high note (*The New Mexican*, June 21, 1959).

> *Folk plays are usually a digest of human experience in story form. Playing out a story and telling it hardly ever bring the same results. The charm of a marionette play is in the surprise element nowhere else possible, there too marionettes can become folk in their own right* (Baumann 1959).

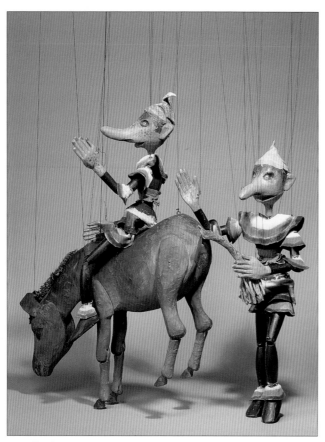

The Duendes and Miguelito, the burro. Collection Museum of Fine Arts. Photo by Herb Lotz, courtesy The Wingspread Collector's Guide.

Baumann based many of his plays on New Mexico folk legends. The marionettes he carved for those plays helped tell his version of the folk stories. His favorite New Mexican folk character must have been the *duendes*, because he carved six of them. Like *brujas*, or witches, duendes come straight out of New Mexico folklore. Baumann called them a local version of the "little people" who appear in cultures all over the world, such as the leprechauns of Ireland. He described them as "impish creatures, full of fun and mischief and practical jokes, without malice or evil," who liked to make life difficult for big people. Two of Baumann's plays, *Santo Niño Visits Casa Escudero* and *San Ysidro* came out of Spanish New Mexican folk tradition. Many local legends grew up around the miraculous deeds of Santo Niño de Atocha (The Holy Child of Atocha). Baumann dressed his Santo Niño in the traditional brimmed hat and mantle. In the old days, people would make

extra pairs of shoes for the saint because it was said he wore out his shoes walking so many miles in the night to help people. In keeping with tradition, Baumann also made an extra pair of sandals for his Santo Niño marionette.

In Baumann's play, *Santo Niño Visits Casa Escudero*, the saint performs several miracles. In the story, Juan and Rosina are getting ready for a fiesta. The Duendes interfere with their plans by driving Juan's burro, Miguelito, away. While Juan goes searching for Miguelito, the Duendes bring a Goat into the kitchen to tease Rosina. When she chases them, she sprains her back. Now she won't be able to finish the rug she was planning to sell at the fiesta, and Juan can't find Miguelito to carry the rug. Santo Niño rescues them both: he heals Rosina's sprained back and finds Miguelito for Juan. He wears out the new shoes Juan made for him while performing these household miracles.

San Ysidro (Saint Isidore) is the patron saint of farmers, who pray to him for rain and to ask him for help against drought, cloudbursts, and plagues of insects that might ruin their crops. Baumann portrayed San Ysidro in the traditional folk manner with a yoke of oxen and a plow.

Baumann's play *San Ysidro* begins with the saint plowing the field on his feast day. Rosina comes to get him. She's ready to go to the fiesta and can't believe that he's plowing on his own holy day! San Ysidro doesn't listen, he just wants to finish plowing so he can plant his crops. An angel comes down from heaven and tells Ysidro that God will be mad at him. The saint tells the angel to go away. The angel comes back and tells Ysidro that God is going to send a cloudburst if he doesn't stop plowing. San Ysidro sends the angel away again and continues plowing. God sends the angel back down to earth with threats of drought, then of insects. The saint just goes on plowing. At last, the angel brings the news that God is really mad now, and he's going to send a bad neighbor! Immediately San Ysidro stops plowing. He and Rosina go to the fiesta and dance.

The threat of a bad neighbor also comes from New Mexican folklore. In Spanish Colonial times, people depended on neighbors for their very survival. The wicked character in New Mexican folk tales, La Malogra, comes from the expression *la mala obra*, which means "the evil deed." Bad neighbors fell into the category of evil doers, people who tried to cause harm to others. Even in today's Hispanic culture, having a bad neighbor is considered a curse (Torres 1995).

With his plays and characters, Baumann helped preserve New Mexico's cultures through his marionette theater. He also helped preserve New Mexico's history in another way, when his woodcarving skills were used to restore the Catholic Archdiocese's beloved statue of Nuestra Señora La Conquistadora. The oldest statue of the Virgin Mary in the United States, Our Lady of the Conquest was brought to New Mexico in the Spanish reconquest of 1692 and enshrined in the Cathedral of Saint Francis.

Most of Baumann's marionettes were twenty-two inches high or smaller. However, he did get the chance to make one giant puppet that started a tradition at the Santa Fe Fiesta. In 1926, Baumann and Santa Fe artist Will Shuster decided that the annual harvest parade and festival, the Santa Fe Fiesta, was too dull. It needed some kind of spark—like a bonfire. They came up with the idea of creating Old Man Gloom, a giant effigy to burn troubles away. Inspired perhaps by the giant Shalako figures he saw at Zuni Pueblo, Baumann created the monstrous "puppet" which came to be known as "Zozobra." The first Zozobra stood eighteen feet tall and had a head made out of a cardboard box. People were delighted and thrilled with the burning of Zozobra, a tradition that continues unabated. Today's Zozobra is forty feet tall.

Demons, witches, saints, angels, simple people and charlatans parade through these playlets in charming complexity. For the child in the audience it is a thrilling experience, and for the adult, who has not lost his capaci-
ty to be charmed by a fairy tale, it is a continual delight.
—*The New Mexican, June 21, 1959*

In 1972 Jane Baumann gave her late husband's entire marionette theater to Santa Fe's Museum of Fine Arts. Her gift included not only the marionettes, stage, scenery, and properties, but also scrapbooks, scripts, photographs, designs and drawings, and even marionette parts. Through this gift the people of New Mexico and visitors from other places continue to benefit from Baumann's talents as a craftsman and his love and interpretation of New Mexico's folklore and culture. His marionette theater both links to the age-old puppet theater traditions and continues them. Baumann achieved the same purpose with his marionette theater as puppetry does, any time, anywhere in the world. Puppets connect people to the deeper meaning of human expression, of ritual and life itself.

The gift of the marionette theater added a new dimension to the large collection of Baumann's prints and paintings the Museum of Fine Arts already owned. Now came the responsibility of caring for the marionettes, making sure they were properly housed and preserved. The museum also wanted to exhibit the marionettes, and some of them appeared with exhibitions of Baumann's other works. However, the museum had a problem with the marionettes. They were not only works of art, they were performers. So, how could the museum help the marionettes continue to do what they did best?

In 1994 the Museum of Fine Arts decided to make the Christmas performances that had started at the Baumann home part of its annual holiday gift to the community. The museum recognized that Baumann's marionettes were fragile, one-of-a-kind objects. To protect the original marionettes, the museum commissioned artists to make replicas. Slowly over time, the replicas are replacing the original marionettes and protecting them from damage.

The next challenge the museum faced was how

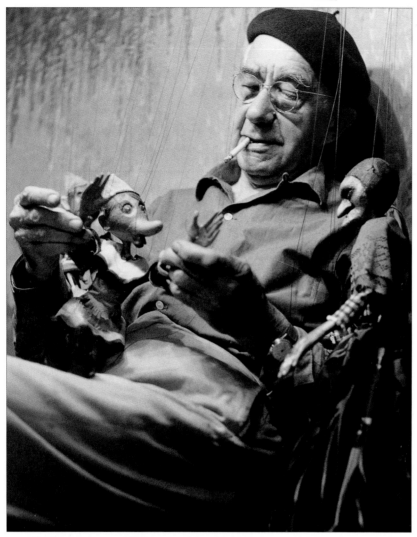

Gus Baumann, ca. 1959. Courtesy of Ann Baumann.

REFERENCES

Acton, David, Martin F. Krause and Madeline Carol Yurtseven. 1993. *Gustave Baumann Nearer to Art*. Santa Fe: Museum of New Mexico Press.

Albuquerque Journal, June 8, 1959.

Baumann, Gustave. 1959. Unpublished notebooks. Museum of Fine Arts archives. Santa Fe, New Mexico.

Dering, Florian, ed. 1988. (with Ann Feucher-Schawelka) *Kasperl Larifari: Blumenstrabe 29a: Das Münchner Marionetten-Theater 1858-1988*. Hugendubel: Munich, Germany, 9-13, 19-20, 93.

McPharlin, Paul. 1969. *The Puppet Theatre in America: A History with a List of Puppeteers 1524-1948*. Boston: Plays, Inc.

The New Mexican, May 12, 1959, June 2, 1959, June 21, 1959.

Puppetry Journal, May-June, 1959: 9.

Rains, Diane. 1991. "Punch 'n Dickens," *T. C. Puppet Monitor*, St. Paul, Minnesota. © Freshwater Pearls Puppetry, 1991.

The Rocky Mountain Herald January 9, 1971: 1, 8.

Till, Wolfgang. 1986. *Puppentheater: Bilder, Figuren, Dokumente*. Munich, Germany: Universitätsdruckerei und Verlag Dr. C. Wolf und Sohn: 23, 98.

Torres, Larry. 1995. *Los Cocos y Los Coconas: Bogey Creatures of the Hispanic Southwest*. Taos, New Mexico: Larry Torres, s.v. "La Malogra."

Tyroller, Stefanie. Correspondence with author. February 1, 1999.

to present the marionettes. Because no one on staff was a puppeteer, the museum hired professional puppeteers from New Mexico to adapt Baumann's scripts for today's audiences and to get the replica marionettes ready to perform. New generations of New Mexico puppeteers are making the Baumann plays and characters come alive again.

The Museum of Fine Arts needed another way to show people Baumann's marionettes when they weren't performing or on display, and a way to show the part his Teatro Duende played both in the history of New Mexico and American puppet theater. This book is the result. It is dedicated to the memory of Gustave Baumann and to people who love puppets.

Acknowledgments

by Elizabeth Cunningham

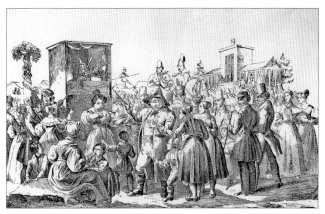

The Fair at Cannstadt (1835) by Johann M. Voltz. Courtesy of the Puppet Theater Museum Collection, City Museum of Munich, Munich, Germany.

Tracking the wild, sometimes elusive *titeres* (puppets) takes some detective work. To find them means searching in many different places, not only under the subject of puppetry, folk art, or folklore but also in history, anthropology, and theater. The following list names the people who gave generously of their time and resources to help with the essay.

Historians and museum professionals in the United States: Diana DiSantis, Cheri Doyle, Donna Pierce, Anita McNeece, Marc Simmons, Joan Tafoya, Robert R. White, and M. Jane Young; in Germany, Dr. Wolfgang Till and Manfred Wegner, Munich, and Stefanie Tyroller, Magdeburg.

Puppet People: Michael McCormick, Rick Morse, and Steve Ortiz.

Librarians and archivists in the United States: Diane Bird, Carroll Botts, Judith Bronner, Mona Chapin, David Herzl, Laura Holt, Mary Jebsen, Nita Murphy, Phil Panum, Joan Phillips, Willow Powers, Judith Sellars, and Michael Swick; in England, Ann Loden and Rigmor Batsvik, Oxford.

A very special thanks to Bonnie Anderson, Mary Wachs, Ann Baumann, Sally Schrup, and Skip and Micah Miller.

Afterword

by Stuart A. Ashman, Director, Museum of Fine Arts

Museums around the world usually have an area of particular strength or some unique collection or characteristic that stands out. El Prado is known for its massive collections of early Spanish masters—Goya, Velázquez, and others; MoMA for its collections of European Modernists; the Whitney for its challenging biennials. In short, something immediately comes to mind when one speaks of these well-known museums.

The Museum of Fine Arts in Santa Fe reflects the dynamic development of the region.

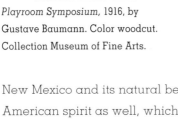

Playroom Symposium, 1916, by Gustave Baumann. Color woodcut. Collection Museum of Fine Arts.

Highlighted in our collections are the works of Los Cinco Pintores, artists who are credited with helping to establish Santa Fe as an important artistic colony; the Taos Society of Artists; early New Mexico Modernists and Transcendentalists; and major American and international photographers who contributed to the history of the region. However, when one thinks of New Mexico and its most important artists, Gustave Baumann is in the forefront of this group, and the Museum of Fine Arts collection of his work is without equal.

Baumann enriched the New Mexico cultural environment by bringing his great talents to the region and contributing to its rich artistic mix. He is perhaps best known for his masterful color woodcut prints, although he was an accomplished painter as well, both of which brought forth his evident love of New Mexico and its natural beauty. His prints and paintings sensitively depict the Native American spirit as well, which he represented with great reverence in his Shalako studies and other renderings, and his abiding respect for the Hispanic culture of Northern New Mexico, of which he became an honorary participant, is represented lovingly with his marionette characters and stories.

Baumann had an enduringly close relationship with his community and with the Museum of Fine Arts. We are very fortunate in having the largest and most complete collection of Baumann's work, due to the generosity of the artist and his family. The Museum of Fine Arts has in its collection nearly 900 works of art created by the hand of Gustave Baumann. Included in this astounding collection are some 787 woodblock prints and paintings, spanning his early years in commercial art, his student works from the Munich period, prints made between 1910 and 1916 when he was a member of Indiana's Brown County art colony, travels east and west, and most centrally works executed during the half-century he lived in Santa Fe. Added to this richness are 72 marionettes, 30 original scripts for performing the marionettes, and more than 200 stage props and ephemera.

This publication represents one of the Museum's efforts to provide recognition for this

unique artist and to share with his community some of Gustave's wonderful gifts. In 1993, David Turner, former director of the Museum, and Sandra D'Emilio, late curator of the Museum, organized an exhibition in honor of Gustave Baumann. In conjunction with that exhibition, a performance of the Baumann marionettes was staged in the Museum's Saint Francis Auditorium. The success of the event and the enthusiasm of the community led to the Museum of Fine Arts' continued commitment to present the marionettes on an annual basis as the highlighted event of the holiday season.

The Museum of Fine Arts wishes to acknowledge the City of Santa Fe Arts Commission for its support of the Baumann marionette performances, which they have funded annually since 1995. I would like to extend my personal thanks to Crosby and Bebe Kemper and the Kemper Foundation of Kansas City for their generous support of this publication; Wood and Anne Arnold for thoughtfully providing the introduction to the Kempers and for their consistent support of the museum and other cultural organizations in New Mexico; Elizabeth Cunningham for her insightful and thorough essay; at the Museum of Fine Arts, Mary Jebsen, Librarian, for her assistance in the research for this project. A special mention must go to Bonnie Anderson, Assistant Director, who was inspired by the beauty and character of the marionettes, and, together with Sandra D'Emilio, developed the idea for a Baumann Marionette book that would be appreciated by people of all ages. It was she who kept the idea alive and the project on track. Appreciation is extended to Mary Wachs, for organizing the material and adding an expert professional touch to the process; Mary Sweitzer, for her innovative ideas in graphic design; Cristina Masoliver and Los Titiriteros de Taos, for bringing the marionettes alive through their skillful puppeteering and sensitive handling of the Baumann scrips; Dana Newmann, storyteller, who with her voice and gestures creates a bridge between the marionettes and the children in the audience; Loren Kahn, director, Loren Kahn Puppet Theater of Albuquerque; and Muriah Love, who along with Cristina works diligently on a replication project to make the marionettes more accessible to wider audiences. And to Ellen Zieselman, Curator of Education, who has, for many years, been an advocate for the work of Gustave Baumann. Through her special gifts and enthusiasm for working with children of all ages, Ellen has contributed a great deal to the public's appreciation and understanding of Baumann's work. Through this publication, Ellen continues to demonstrate her great love and deep understanding of the spirit of Gustave Baumann's work.

I would also like to give special mention to Ann Baumann, the artist's daughter, for her commitment and support of our efforts to preserve the legacy of this important artist.

I sincerely hope that you find reading this book an enjoyable experience, and may it serve as a memento of the wonderful performances of the Baumann marionettes.

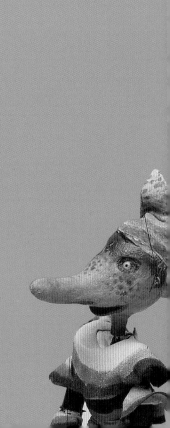